CALLIGRAPHY

er eye, which
y messenger

PUCK How now mad spirit?
ut this haunted grove!

Then what it was that...
she must dote on in extremity?
What night

. Robin
Goodfellow

PUCK

s with a monster is in love.
ted to war, while she was in her
w of patches, more
d upon ... chamber ... that ek
near to her close and sleep

ATHENIAN stalks

hearse a play intended for
t nuptial day. The shallowest thickskin
sort, who Pyramus presented in their sport
ene 2
in
n I did
advantage

TITA

ushead Anon his ... I see
y mimic comes. When
ng, fowler eye; or
monges, many in
cawing at the
emselves and

CALLIGRAPHY

SKILLS AND TECHNIQUES

JUDY MARTIN & MIRIAM STRIBLEY

MACMILLAN
U.S.A.

MACMILLAN

A Prentice Hall Macmillan Company

15 Columbus Circle

New York, NY 10023

Library of Congress Cataloging-in-Publication Data

Martin, Judy (Frances Judy)
 Calligraphy skills and techniques / Judy Martin and Miriam
Stribley.
 p. cm.
 Includes index.
 ISBN 0-02-022655-1
 1. Calligraphy — Technique. I. Stribley, Miriam. II. Title.
NK3600.M26 1994 94-15246 CIP
745.6'1—dc20

Manufactured in Spain

10 9 8 7 6 5 4 3 2 1

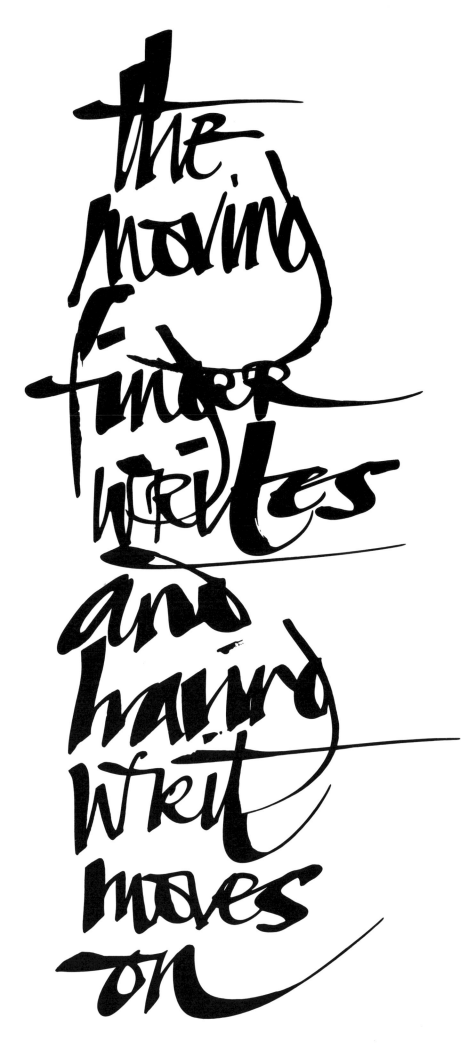

CONTENTS

INTRODUCTION

Calligraphy is a rediscovered art brought back from earlier centuries by modern scribes who looked to the past for inspiration on beautiful, highly crafted handwritten lettering. Old manuscripts reveal how writing that was meant to be strictly practical, as it was the only means of recording and distributing information, could also be elegantly formed and laid out. Much of the work was also ornamental, illuminated with colors and gold.

The essential shape of modern western languages was established with the 23-letter Roman alphabet; the letters J, V and W were later additions. The classical square capitals, as seen in inscriptions on stone, were finely crafted and proportioned "display" letters; less formal scripts were used for making records on papyrus, wood or wax tablets.

The exact forms of writing are always influenced by the tools and surfaces used. Incised letters in stone or wood have a different character from pen letters. By the time a modified form of square capitals, known as uncials, became commonly used in Christian monastic settlements, reed pens had been replaced by more flexible quills, and parchment or vellum (treated animal skins) were used instead of the coarser papyrus that were made from plant fibers. Both reed pens and quills had an edged nib, which naturally created the thick and thin stroke variations which are typical of most modern calligraphic writing.

Parchment and vellum could be made into folded or bound books, so uncials a further modification, are referred to as book hands. They are defined as majuscule letters, equivalent to capitals. The greatest change to writing since the development of the Roman alphabet came with a newly designed alphabet introduced in 8th-century Europe, the Carolingian minuscule, named after the Emperor Charlemagne who ordered a scholarly revision of scripts. Minuscules were the model for "small" letterforms, as distinct from capitals.

Variations in scripts occurred through practical considerations, like the need for economy when copying standard texts or recording large amounts of information. Compressed and angular letterforms resulted, notably the narrow, heavy black letter of northern Europe. In the south, lettering styles were typically more rounded and classical in inspiration, but in Renaissance Italy evolved into the branching, slanted italic script which is still in use for ordinary handwriting, as well as in more formal calligraphic styles.

Both black letter and italics were taken as early models for typefaces, but as printing became efficient and relatively inexpensive, the style and intention of formal writing skills altered. In the 17th century, handwriting was influenced by engraving techniques. "Copperplate" writing with a narrow-tipped pen was reproduced in copybook form by engraving

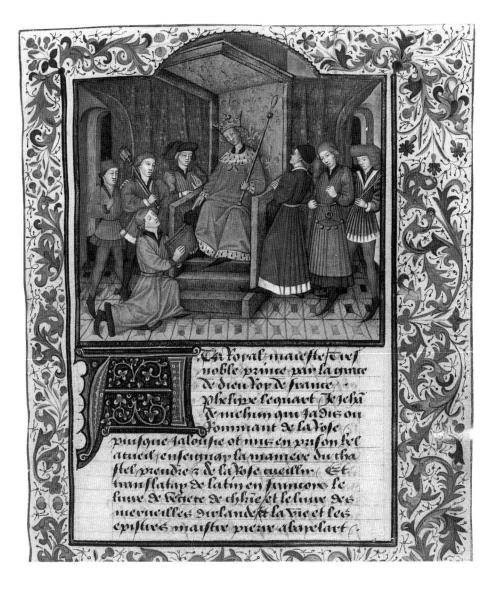

Above: A page from the Bedford House Psalter.
Opposite: A French manuscript with a cursive Gothic form.

on metal with a pointed tool. The scripts were finer and more flowing than edged-pen lettering, and the copybooks often encouraged ornamental styles. As literacy became more widespread and writing styles more personalized, while printing guaranteed the clarity of texts for mass publication, many complex and frequently inelegant scripts were devised.

Metal pens came into general use in the 19th century, with pointed nibs as standard. During a period of Gothic revivalism, designers became interested in the styling of text and decoration in old manuscripts, but they could not directly recreate the letterforms that had been naturally formed by the square-cut quills. This important practical aspect of the craft was rediscovered by a few artists and teachers in the early 20th century, who analyzed the antique forms and created a body of knowledge about how they were made. The work of influential practitioners led to the development of modern calligraphic standards which have produced a rich diversity of lettering and handwriting skills. Calligraphy today is an increasingly popular and inventive art.

Materials
and
Techniques

MATERIALS AND EQUIPMENT

Calligraphy is an economical craft and you can learn the basics and progress quite far with a minimum of tools and materials. The essence of modern calligraphic style comes from the use of an edged writing tool, not a point. Metal pens are most commonly used but the range of writing instruments that you can try includes reed pens or quills, markers or brushes. Suitable inks, paints and papers are widely available from stationers and art suppliers, but there are also specialist retailers who can introduce you to a wider variety of calligraphic materials as your work grows more confident and adventurous.

Metal pens

Dip pens are ideal for calligraphy, because they are compactly made, versatile and durable. Penholders can be fitted with interchangeable nibs so that you can easily alter the width of the writing edge to suit your project. Most nibs are made with an integral ink reservoir sited over or under the nib, above the writing edge; some types will take a separate slip-on reservoir to control or vary the flow of ink.

Standard nib widths for square-cut or edged nibs range in size from about (½-¼ in) ½-5mm and are defined by actual measurement or numerical code. Poster pens, so-called from their association with large-scale display writing, include much broader nib sizes. In standard nibs, the writing edge may be cut straight across, right-oblique, or left-oblique that are specifically designed for left-handed writers. There are also pens in which the nib is fixed to the holder. These include some more specialized types such as automatic pens, which have broad-edged nibs made from lozenge-shaped metal strips, and Coit pens, in which the writing edge is divided into separate teeth that automatically produce multiple, parallel strokes. These vary in both the number of teeth and in coarse to fine spacings. Single pens of these types are less versatile than holders and loose nibs for initial exercises and learning projects, but often become favorite tools for large lettering and special effects among practiced calligraphers.

Fine, pointed pens, such as a crow quill or mapping pen, cannot be used to imitate edged-pen calligraphic styles, however they may be useful for delicate ornamentation and background detail. The only traditional writing style that requires a pointed nib is copperplate, and copperplate nibs with a straight or an angled shaft are available.

Reed pens and quills

Calligraphy has a long history and tradition in which metal pens are a relatively recent introduction. Formerly, natural hollow-shafted materials were used, primarily reeds or quills. Reed pens are quite easy to make; gardeners' canes are an acceptable substitute for reeds. On a section about (8in) 20cm long, one end is sliced at an oblique angle and the sides of the cut section are shaved down to form "shoulders", imitating the familiar form of the metal pen nib. A vertical slit is cut into the tip in order to facilitate the ink flow and the writing edge can then be cut straight across or obliquely angled.

Reed pens typically give a broader and cruder stroke than metal pens, but this has a boldness and vitality that are well suited to modern calligraphy. The hollow center forms a natural ink reservoir but it can be difficult to obtain an even flow. Soak the trimmed end in ink before you start to use the pen for writing, as the material is absorbent.

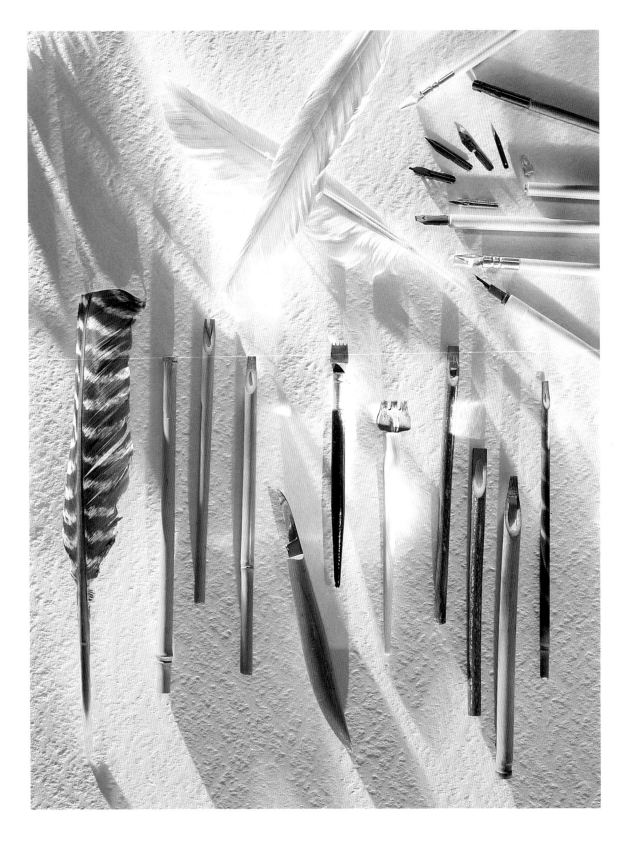

Above: Reed pens and quills are traditional scribes' tools,
although many modern calligraphers prefer the
convenience and variety of purpose-made metal pens.

Quills — pens made from feathers — are much finer and more flexible, but drying and trimming quills yourself is quite a lengthy task. Prepared quills are available; large goose or turkey feathers are often used, though finer tools are also made from duck and raven feathers (see page 13). Quill tips wear down in use and have to be re-cut frequently.

Fountain pens

Calligraphic fountain pens are widely available. They are clean and easy to control, and the built-in, long-lasting ink reservoir (usually an ink cartridge) saves trouble. The main disadvantage of a fountain pen is that the largest nib size is relatively small compared to dip pens, limiting the scale and texture of the work, and the nib is compact and less flexible.

Felt-tips and markers

Fiber- and felt-tip pens that are designed specifically for calligraphic use have broad, square-cut tips that imitate the writing edge of a metal pen. They are attractive and useful tools for free practice of basic letterforms and the comfortable feel of a pen associated with everyday use can help you to relax about learning new aspects of your craft. Pens and markers are also valuable tools for making quick roughs in order to develop a design that may be carried out in other materials.

For finished work, there are two things to beware of. One is that the tip gradually wears down, so a well-used pen may produce inconsistencies in your letterforms — fiber-tips suffer this less quickly than felt-tips. The second is that some markers are manufactured primarily for use in work which is either intended to be temporary or else is likely to be reproduced — for example, design and illustration work — and the inks are not necessarily consistent or permanent, especially if you are using colors. For this reason you should check the permanency ratings of pens, if they are specified, and do not rely on the color values of inexpensive felt-tip pens.

Pointed fiber-tips are suitable for fine flourishing or decoration; some types are available in a very wide range of colors. You can also write skeleton letterforms with them, or bind two fiber-tip pens together and use them like double pencils, for practicing letter construction in a way that imitates edged-pen action (see the illustration on page 24).

Brushes

The equivalent to the edged pen is a square-ended brush. Sable brushes, usually sold for watercolor painting are ideal, high-quality tools, but there are many types of synthetic hair brushes which are also good and consistent in quality, and they are much less expensive. Choose a brush in which the hairs are long enough to act as an effective reservoir for ink or paint, but not so long that they flip and spread on the paper, giving you little control of letter shapes.

Roundhair sable or synthetic brushes are useful for applying background color and ornamentation. These range in size from very fine, small, dagger-like points to generous, swelling heads tapering to a pointed tip. The sizes you require will naturally relate to the type of work you wish to do with them. Another, perhaps unexpected, use of the brush in calligraphy is for loading the pen. You hold the brush in your non-writing hand and feed ink directly into the pen reservoir. The dual action takes some getting used to, but it can help you to control the flow and density of ink or diluted paint very precisely. However, it is not obligatory, and you may prefer the convenience of simply dipping the pen.

Oriental brushes, sometimes made from attractively exotic materials such as duck down or peacock feathers as well as hairs, are stocked by specialist suppliers of calligraphy materials. The brushes are broad and soft, giving a very fluid stroke. However, keep in mind that the traditions of oriental calligraphy are quite different from those of European pen lettering. You will not be able to relate the shape of

these brushes directly to the construction of formal edged-pen letters, so they will lead you into a different style of work.

Inks

The flow and density of a writing ink naturally affect the finished appearance of your calligraphy, but can also influence your touch and rhythm as you use the pen. You may want to try a few types before you find the one that suits you best, and you may want to vary your inks for different projects in relation to the pen and writing surface you are using. The general rule is to use a non-waterproof black ink for practicing and for finished work in black. Avoid waterproof inks, which are less sensitive to the pen stroke and tend to clog the nib. There are special calligraphic inks, and a wide variety of writing and drawing inks made for graphic work and handwriting that are perfectly suitable for calligraphy. And ink that is too dense and can be thinned with distilled water.

If you use a fountain pen, use a recommended writing ink, as drawing inks can damage reservoir pens. Fountain pen inks tend to give a variable color quality in broad-pen writing, which can be an attractive quality if you use them with a dip pen or brush.

Ink sticks have become increasingly popular; these enable you to grind ink to a required tone and density. The sticks and grinding stones are readily available. The stone is in the shape of a squared dish, and the ink is prepared by putting distilled water on to the stone and rubbing the ink stick back and forth. By noting the quantity of water you use (usually measured in drops) and the amount of time you spend grinding, you can record your method for producing ink of a particular quality.

Colored inks and paints

Modern calligraphers use color inventively, for the actual writing and for background, illustration or ornament. You can use colored drawing inks — colors are typically lighter, more fluid and relatively transparent as compared to black ink. They can provide subtle shading and overlays, but you may need time to get used to controlling the easy flow before starting on finished work in color. Liquid watercolors and acrylic inks act similarly — acrylic ink is waterproof when dry — but these are materials designed specially for graphics and illustration and are not always fully permanent.

Artists' quality paints have the advantages of reliable permanence and a wide color range. Suitably diluted, they are perfectly usable in dip pens and obviously sympathetic for brush lettering. The main choice is between translucent or opaque paint.

Watercolors, which are available in pans or tubes, are very pure paints which give a delicate effect. Like inks, their translucency makes the color density slightly variable and colors can be blended and overlaid in successive strokes. Gouache is opaque watercolor, containing white pigment which makes the colors dry clean and flat. Artists' colors are graded for permanence — some pigments are slightly less reliable than others, but you can build up a large palette of completely lightfast colors. Mix tube colors in a well palette, adding clean water very gradually until you achieve a thin, milky consistency. Although the paint must be heavily diluted in order to flow properly through a pen, make sure that you do not reduce it to watery color; the hues and tones should remain intense and strong.

Gum arabic or oxgall can be added in order to improve the flow and adhesion of the paint. If you need a lot of one color, you should pre-mix a large quantity and store it in an airtight jar; otherwise you will have to keep a careful record of color mixes and dilution to be able to match a specific color when you run out. Diluted paint mixtures are liable to separate if they are left to stand for a time; so stir the paint frequently and, if using a pen, load the color onto the nib with a brush.

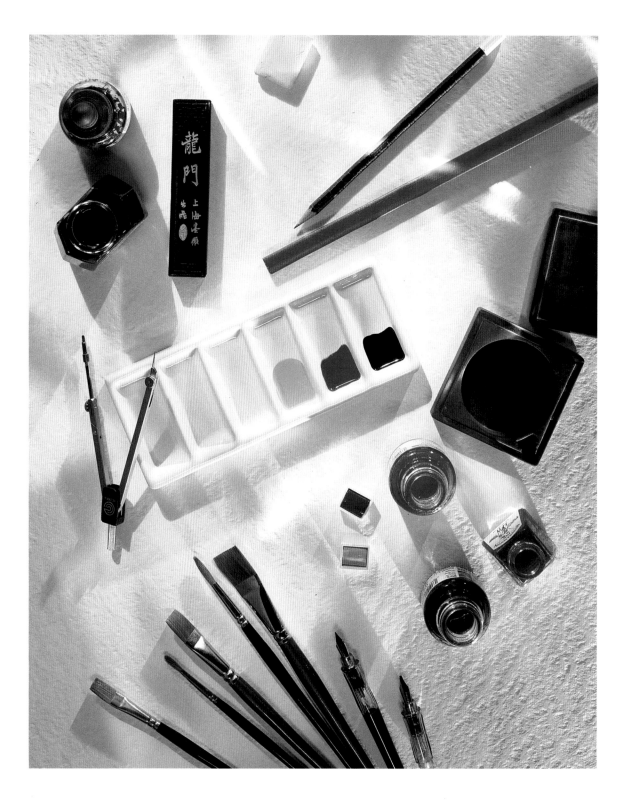

Above: Writing inks and Chinese stick ink are standard
materials, but watercolors and drawing inks add a palette
of vivid colors for decorative calligraphic work.

Papers

You can use almost any type of writing or drawing paper for calligraphy. The important factors are weight, color and surface texture. For practicing letterforms and creating rough layouts, it is easiest to use something smooth and inexpensive, such as bond paper, layout paper or cartridge. After that, it is entirely open to your own personal tastes and preferences, and the nature of your chosen writing surface can have a very influential effect on the finished appearance of the work.

Fine writing papers are categorized as either laid or wove. Laid paper carries a striated pattern of lines that is created by the mold in which it is made. In contrast, wove paper is manufactured and has an even overall texture and finish.

Many papers and thin artboards sold for painting and illustration work will prove suitable for calligraphy. The surface texture and grain of drawing or watercolor papers obviously affect the movement of the pen and the adherence of the ink or paint.

Watercolor papers are generally categorized as hot-pressed (HP) which is the smoothest surface; "not" (not-pressed or cold-pressed) which is a medium grain; and rough, which has a heavy and variable texture. The weight of a paper is measured in pounds per ream (a ream is 500 sheets) or grams per square metre (gsm or gm2), which basically indicates the thickness and flexibility of the paper sheet. Most types are available in different weights, some in cream as well as white, or even a limited color range.

A heavy grain physically consists of bumps and pits in the paper surface, which means that the pen stroke is broken up. In particular, you will not get clean edges to pen strokes on heavy-grained paper, and the internal texture of the strokes can also be roughened. These qualities can be very effective in relation to broad-nib or brush-written letters, but in small-scale writing they can destroy legibility.

Some papers for watercolor work are unsized, which means that the fibers are not sealed so moisture and color can spread into the paper texture. To maintain any crispness in formal calligraphy, you need papers that have been sized; this soaking in glue size gives a more resistant finish.

There are many beautiful colored and fancy-textured papers: colored cartridge; coated and poster papers in bright hues; subtly toned, fine-grained pastel papers; imitation parchment; and delicate oriental papers with mixed vegetable fibers — even whole flowers pressed into the paper pulp. These are all worth experimenting with, although the price range varies enormously and some are extremely expensive. You should always consider the tool you want to use when you choose a paper. A pen will pick at or dig into a fibrous paper, whereas a brush will travel more easily across it. Always test a surface before planning finished work.

General equipment

There are all kinds of studio items, depending on the kinds of work you want to do once you start designing your own projects. Essential equipment for starting calligraphic work is quite basic and inexpensive: pencils, erasers, a ruler, a T-square, set-square or right-angle triangle and protractor, and a sharp craft knife or scalpel for trimming paper.

Pencils are used for drawing up guidelines and layouts, and also for lettering practice of skeleton or double-point forms (see page 20). A generally useful pencil grade is HB, which creates a thin, gray-black line that is easy to erase. For very fine guidelines which need not be removed, a harder, finer pencil such as a 2H or 3H is more suitable; use these grades very lightly, as the point will score your paper if pressed too hard. A carpenter's pencil has a wedge-shaped tip similar to a square-cut nib or calligraphic fiber-tip. This is a good informal tool for quick calligraphy practice and design roughs.

A plastic ruler is ideal for general purposes; (18 in) 45cm is more versatile than the standard (12 in) 30cm rule. For trimming paper accurately, you should use a plastic ruler with a metal edge inset, or a separate metal ruler or straightedge. It is often tempting to cut against a plastic ruler because it happens to be to hand, but invariably the edge becomes shaved by the cutting implement and the ruler is then rendered useless for accurate measurement and ruling.

A T-square, set-square or right-angle triangle is essential to ensure that your guidelines and layouts are even, with the baselines and margins at right angles to each other. And a protractor will help you to set your pen angle accurately (see opposite).

For erasing firm pencil marks, use a soft plastic eraser which actually rubs the graphite off the paper, rather than damaging the fibers of the paper itself which will irreprably ruin the surface. For removing light smudges and fingerprints, a kneadable or putty eraser is most appropriate, which simply lifts the dirt.

Abrasive ink rubbers are very hard on the paper fibers and may destroy the surface finish to the point where you cannot easily overwork. For correcting ink lines, learn to scrape back the ink very gently with a fine blade such as a scalpel, disturbing the surrounding fibers as little as possible.

In some circumstances, particularly black and white work for reproduction, you can get away with covering the ink line with white gouache or type-writer correction fluid. However, for display work, keep in mind that most papers are not in fact pure white, and painted corrections always show up quite clearly and mar the finished result.

For brush lettering and color work, you need a well palette and two or three glass jars of water to hand in order to clean the brush regularly. As you progress, you might want to add a number of different studio items to your stock, such as circle or ellipse templates, French curves, a flexible rule, a compass and other technical drawing instruments (see the illustration opposite). This all depends on how complex your layouts and projects become.

Starting work

Calligraphy is a concentrated activity and you need to be comfortable and well-supported as you work. Always work in a place with the benefit of strong, clear lighting — an angle-poise lamp is the ideal light source, placed close to your work area on the side opposite your writing hand so that no shadows are cast on the paper. If you are able to work in daylight, position yourself by a window with the light falling at a suitable angle.

Working on a tilted surface is recommended, which gives you access and control. Use a drawing board secured at about 45° to the horizontal. If you are working in paint rather than ink, a slightly shallower tilt gives freer flow. A freestanding studio drawing board is ideal, but you can prop up an ordinary drawing board on bricks, books or a table easel, provided it cannot slip away from you while you are working. To create a smooth, giving support which will be responsive to the pen movement, make a pad of a few sheets of newspaper or blotting paper covered with a clean sheet of cartridge paper. This should be larger than the usual scale of your calligraphic work, and firmly taped down on all sides.

As clear, rhythmic calligraphy depends on a consistent pen angle and pressure, it is best to move the paper as you progress widthways or from line to line, rather than allowing your hand and arm to travel too far across or down. A strip of paper along the top of the board, attached with tape, helps to keep the writing paper flat and clean as you move it up — just slip the top edge under the strip. Place a guard sheet at the bottom of the drawing board so you can rest on it while you work. Use cartridge or blotting paper folded in half lengthways; a folded edge is more comfortable to work against than a cut edge.

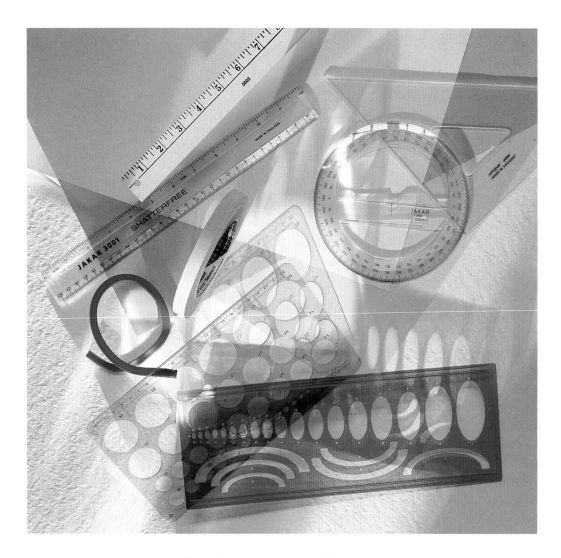

*Above: A ruler, protractor and right-angled triangle are
basic equipment for planning and drafting layouts, and
other drawing aids can be added as you need them.*

For right-handed calligraphers, the writing paper should normally be square to the board, aligned horizontally with the base. Left-handers may have to take a more awkward position to achieve a constant pen angle, so the paper can be turned to make the writing line or area easily accessible. In either case, if you are working on a design in which the lettering is not all organized horizontally, it is again easier to turn your paper to align with the required direction than to manipulate the pen into an uncomfortable position.

It may seem a little curious to point out that your posture is influential, but you need to be well balanced, with feet and back firmly supported. Try to avoid the temptation to hunch over the work, leaning heavily on the drawing board and peering closely at the letterforms. A tensed, bent body gives your hand and arm less freedom and confidence to form the strokes fluidly, and a too-close view can make it difficult to keep a sense of consistency in the weight and proportion of the letters.

TECHNIQUES AND PRINCIPLES

Formal calligraphy has a definite discipline, which you need to follow in order to achieve strong, consistent, well-designed lettering. The principles of broad edged-pen calligraphy have evolved from the practical experiment of modern scribes, originally based on careful analysis of centuries-old manuscript lettering. The motion and logic of calligraphy is quite different from that of ordinary handwriting, or even hand-printing of letters. Typically it is not cursive, in other words running or continuous, and individual letterforms, as well as words and phrases, are constructed by a sequence of strokes. The following guidelines relate to the formal alphabets shown on pages 30-75.

Handling the pen

The edged pen is pulled across the paper, seldom pushed. In practical terms the broad nib resists pushing and when travelling forwards will dig into the paper. But if you have to pull the pen, you cannot form letters in a single motion. In handwriting, to make an O, for example, you simply run the pen round a full circle; to write V, you make a quick down-up movement. In calligraphy, these letters are formed by two separate strokes, running from top to bottom. In between strokes, you lift the pen from the paper. To keep the pen travelling either sideways or downwards, most letters are formed from two or three strokes, though some need four or five. Serifs and terminals, which are the finishing strokes, are often incorporated in the main stroke, but sometimes have to be added. Lifting the pen makes the motion of calligraphy relatively slow and deliberate, but gives formality and consistency to the lettering.

Angle and stress

The edged pen naturally creates thick and thin variations in its strokes that give calligraphic letterforms their shading and elegance. With a pointed pen, to broaden the stroke you would increase the pressure or area of contact with the paper, thus making the nib splay and release more ink. With an edged pen, the thick and thin variations are contained in the direction of the stroke. Pulling the pen sideways makes a fine line as the very edge of the nib skates across the paper; pulling downwards keeps the whole width of the nib in contact with the surface, creating a uniformly thick line.

All the letterforms in a calligraphic alphabet are given consistent stresses and thick and thin variations by keeping the pen angle and pressure constant. Pen angle refers to the angle of the nib edge in relation to the horizontal baseline on which the letters are written. When this angle is constant, curved strokes taper and swell in the same way on partial or whole curves, and the diagonal, vertical and horizontal strokes each have a specific weight and thickness. There is a natural consistency to these elements even though the structures of the letters are different.

An interesting and practical way of understanding how the pen angle constructs the slant and thickness of letter strokes is to try double-point lettering using two pencils or fiber-tip pens bound together (see the illustration on page 24 for a multi-nib effect). The points correspond to the corners of an edged nib. When you make a curved or angled stroke with a double-point, you can see exactly how the lines they make come together or flow apart. The pen strokes

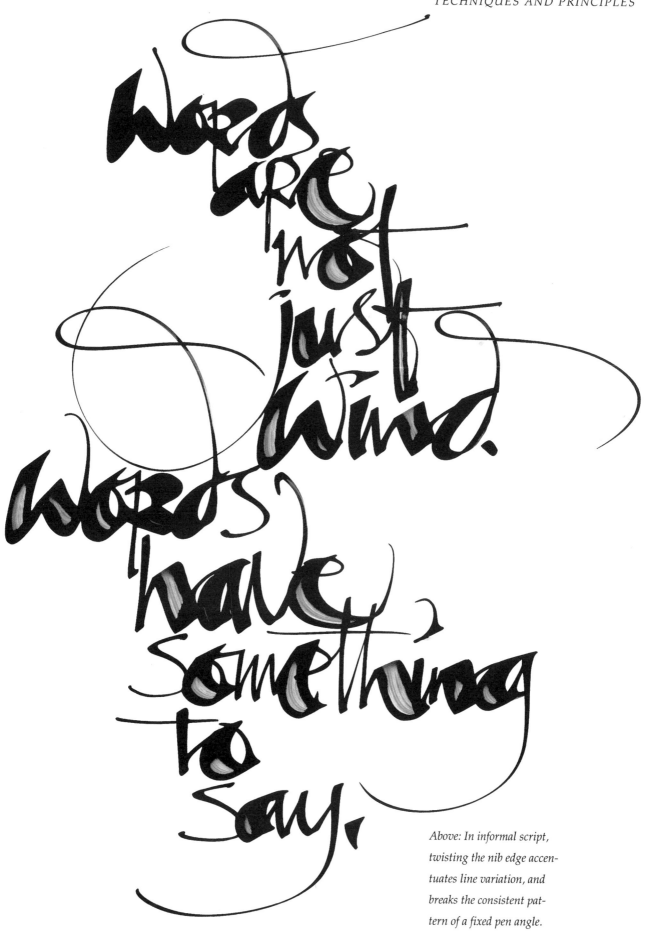

Above: In informal script, twisting the nib edge accentuates line variation, and breaks the consistent pattern of a fixed pen angle.

Above: A modern script based on copperplate; the rhythm
of the layout is anchored by the repeated, rounded O.
Opposite: Thick and thin stresses create a mood of music.

have the same visual logic, but the flat nib edge produces a solid, filled stroke. A calligraphic letterform has a particular stress relating to the thick and thin variations in the strokes. It is governed by the pen angle and you can see it clearly in curved letterforms, which all relate to the letter O. For example, with a pen angle of 30° or 45° the thinnest part of a curve lies on an axis tilted from the vertical. A horizontal pen angle gives a vertical stress.

Character and proportion

Legibility is a primary consideration in calligraphy. However inventive or complex a design may be, calligraphers never forget that they are dealing with the written word. Sometimes, making a visual puzzle is part of the fun of a piece, but for the majority of calligraphic works it is important to be able to read them easily as well as admire their form. This means that individual letterforms must retain their characteristic constructions, as well as their characteristic differences from each other.

Each alphabet style has family resemblances between letters, which derive from their basic shapes and proportions. For example, the way curves branch from vertical stems is generally governed by the shape of the O. In Roman capitals (see page 30) and uncials (see page 36) O is circular, though differently

stressed, and curves pull out quite flatly from the stems. In italic (see page 60) the O is elliptical and arches or bowls branch out sharply, for example, in h and n, b and p. In black letter (see page 48) lower-case forms the o is angular and compressed, and there are no true curves.

A skeleton alphabet shows you the most basic shapes, and the proportions of the letters. The skeleton form is precisely that, the underlying construction of the letter which is fleshed out by the thick and thin pen variations. In capital forms, the skeleton letters are a uniform height. In lower-case, or small, letterforms, the skeleton proportions include the body of the letter (known as the x-height, in typographic terminology) and the length of ascenders (which are the rising strokes as in b, d, h) and

descenders (the strokes that fall below the writing line as in the tail of g or y). Proportions are consistent in the same way that basic shapes are; they have common relationships according to parts of a letter. The bowl of b, for example, will not be radically different in form and size from that of d; the full curve of C corresponds to that of G.

Proportions are not formally laid down for most alphabets, though Roman capitals, which were not originally natural pen letters, have a defined set of geometric relationships (see pages 32-33). Proportions vary according to the style of the letterforms. For instance, in uncials the relative widths of "middle-sized" letters such as E, F, H and N are occasionally surprising, and different from the way that they appear in Roman capitals. The compression of slanted

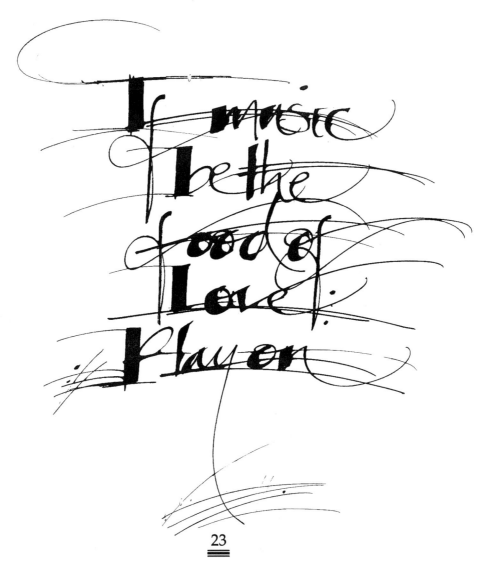

Above: A multi-stroke nib, such as a five-pointed music pen used for ruling music staves, shows up the letter structures and flow of the strokes.

or angular styles such as italic and black letter tends to minimize width variations. Then also, there can be different interpretations of a lettering style, which may depend on slight adjustments to letter proportions or skeleton shapes.

Ascenders and descenders are best not exaggerated in relation to the body height of the letter, though they are sometimes flourished or extended to give style to a design. When capitals and lower-case letters are combined, the height of capital letters usually falls slightly short of the full extent of the ascender in the lower-case form. It is possible to combine capitals and lower-case letterforms of completely different styles quite successfully, in which case you can only judge relative proportions by eye.

Height and weight of letters

A relationship between the height and weight of letters is established by using the width of the nib as the common factor. Height is not selected as an arbitrary measurement, but constructed as a "ladder" of nib widths, marked off with the nib edge held at right angles to the horizontal baseline.

A height of four nib widths produces a relatively heavy letter, whereas six nib widths makes a more slender, open form. You should refer to the alphabets in the Alphabets chapter (see page 28) for specific nib widths to adopt for recreating particular alphabets. Keep in mind that the nib width shapes not only the letterform but also its internal spaces, which are known as counters. Below four nib widths in height, the counters may tend to fill in. Whereas above six nib widths in height, the curves become more slender and extended, and the shapes are more difficult to control. Seven nib widths to height is a recommended maximum. In lower-case forms, the ascenders and descenders should be measured proportionately in the same way. For example, as three nib widths each above and below four nib widths x-height. If the width of the nib relates directly to height in this way,

then it becomes obvious that letters of the same height written with different nib widths will have different weights. A narrow nib fits more times into the overall height than a large one, its letterform is therefore lighter and more open. A wide nib makes a thicker stroke giving boldness to the letter. So, there are two ways to adjust weight: keeping the height constant and varying the nib width, or keeping the nib size constant and allowing more nib widths to height. If you are combining different calligraphic styles, you will need to set a measurement for one and then find the appropriate nib width and height for additional forms.

Calligraphic lettering also has weight and texture *en masse*. The shapes and stresses of individual letters, the spacing between letters, words and lines and the relationship of written areas to overall space also contribute to the density of a block of writing.

Spacing and layout

To start practicing letterforms, all you need to do is rule baselines on which the letters can sit, and possibly a left-hand margin, then mark off your ladder of nib widths from the baseline to give you the height. Many calligraphers recommend that you do not rule the upper limit of the letters, or separate lines for the beginning and end of ascenders and descenders. Calligraphy is about developing touch and rhythm in your letter construction, not fitting things into prescribed slots. To begin with, you will get the shapes and letter spacing wrong, but gradually your eye for form and proportion will improve. Using ruled "tramlines" to guide the construction of letters was memorably described by the English scribe Edward Johnston (1872-1944) as "trying to dance in a room your own height".

At first you can practice individual letters quite randomly, but soon you will want to combine them into words and phrases. There are no easy guidelines for spacing between letters. It is variable, according

to whether the adjacent letters are upright, angled or curved, similar in form and width or very different, and the particular combination of letters within a word. Here again, you will develop an eye for it as you become more familiar with the letterforms.

For word spacing, there is a basic rule of thumb; space between words written in lower case approximates to the width of n, and between capitals to the width of O. But you may wish to adjust this depending on the style of writing that you are using, the formality of the design and its overall texture.

Line spacing is largely a matter of personal preference. If you are writing something clean and formal, say, an invitation or a commemoration, you should aim to set line spacing that keeps the text attractively massed but at the same time allows enough room for ascenders and descenders to stand clear of each other. In informal and experimental work, allowing some or all of the letters to touch or even overlap between lines can add a sense of vitality. The only standard is your own judgement of the legibility of the piece.

As you come to designing your own projects, you will need to make a lot of rough versions that explore the different options for positioning calligraphy on the page. To organize a block of lettering formally, you can follow four basic layouts. These are: aligned vertically at the left margin and falling free or "ragged" on the right; aligned on the right and falling free on the left; aligned evenly on both sides or centered and falling "ragged" on both sides. A large quantity of writing usually needs to have some definite order, but short texts, such as brief quotations, logos or verses, can alternatively have a free, asymmetric design.

If it matters that the layout is precise, you should make some rough versions of the line lengths as you have them planned. A practical way to do this is to cut the proposed line lengths into strips of paper

Above: A narrowly shaped,
left-aligned layout.

and then paste them in position on a separate sheet of paper using baselines and margins as a guide. To arrange centered text, fold each strip in half and mark the center point, then rule a center line on your layout and align the strips to the central line. Whatever you arrive at in this way, you can then measure up a grid for the finished work from your rough paste-up.

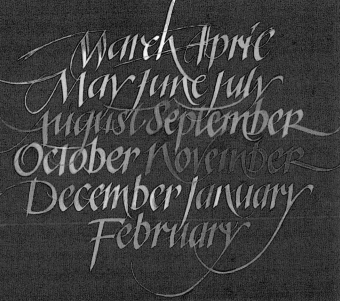

Above: A clever fit for free lettering, with long tails breaking the alignment. Right: An unusual calendar design. The lines are centered on a vertical axis, with words grouped to vary the line lengths.

Alphabets

ROMAN

*Above: A detail showing Roman
capitals, see the manuscript opposite.*

Roman lettering is the foundation of modern calligraphy. It has provided the basic elements of the alphabet we now use, in standard, well-shaped, proportioned forms. The classical square capitals were used for inscriptions carved in stone, which provide most of the surviving examples. As pen letters, they are more fluid and weighty, yet it is important to preserve their clarity and fineness.

The proportions of Roman capitals relate to the circular O, which fits into a square. Other rounded forms follow the circle within the square: Q is complete like O; in C, G and D, the circle is cut through at nine-tenths of the square. In M and W, the outer oblique strokes extend outside the square slightly, giving balance to the width of the letters. Letters composed of straight lines or stems and bowls fit into rectangles which are either half or eight-tenths of the square, divided vertically.

These proportions are shown in the skeleton alphabet overleaf. It is useful to practice the skeleton shapes, which you can do with a pencil or felt-tip pen, before starting to write the formal capitals with an edged pen. Some adjustments are needed for positioning cross-strokes to obtain a correct optical effect. The horizontal bar through A is a little lower than halfway down, whereas in B, E, F and H the cross-bar is slightly above center. The upper bowl of B is also above, as is the diagonal of K, while in R the lower curve drops below center.

A proportionate lower-case alphabet is also shown in skeleton form. There was no direct contemporary equivalent for Roman capitals: the modern lower-case letters relate to the Caroline minuscule (see page 40). Because there are more rounded letters in lower-case, several of these take the proportion of nine-tenths of the square.

The edged-pen capitals shown on pages 34-5 are written with a pen angle of 30°. Classical letter height is ten times the width of the main stroke; eight or nine widths can also be used, but at seven or below the forms become too heavy and squat.

Draw the serifs at right angles to the main stroke and curve smoothly in or out. Ideally, the curve is an exact quarter-circle on either side of the stem, but for practical purposes curves should be even and uniform, not angled or abrupt. The full serif is made of short curving pen strokes from opposite directions, finished with a fine, flat hairline. Hold the nib horizontally to make these strokes. On the cross-bars of E and R, make the serif holding the nib edge vertically.

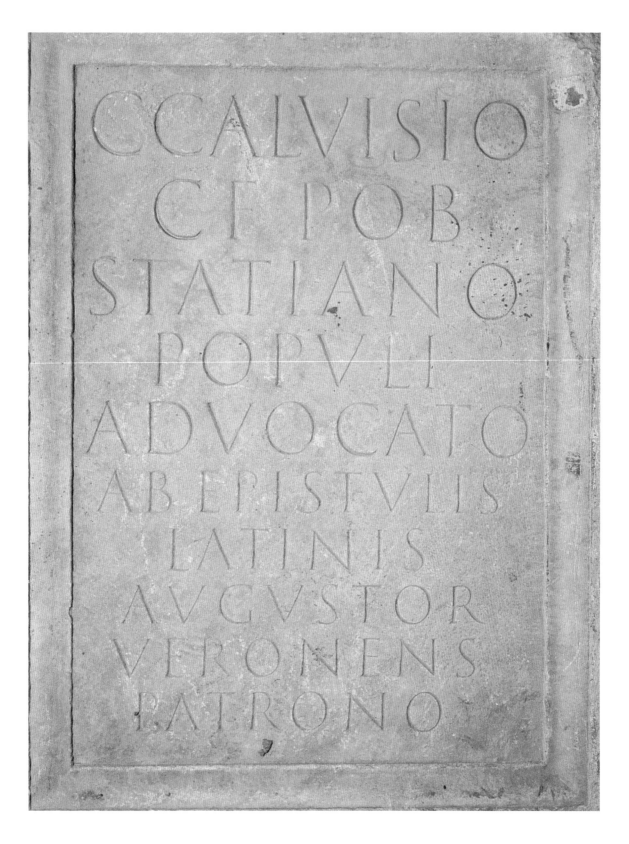

Above: This stone tablet dates from the 2nd century AD.
Inscriptions on stone glorified the authority of the powerful
Roman Empire and its privileged citizens.

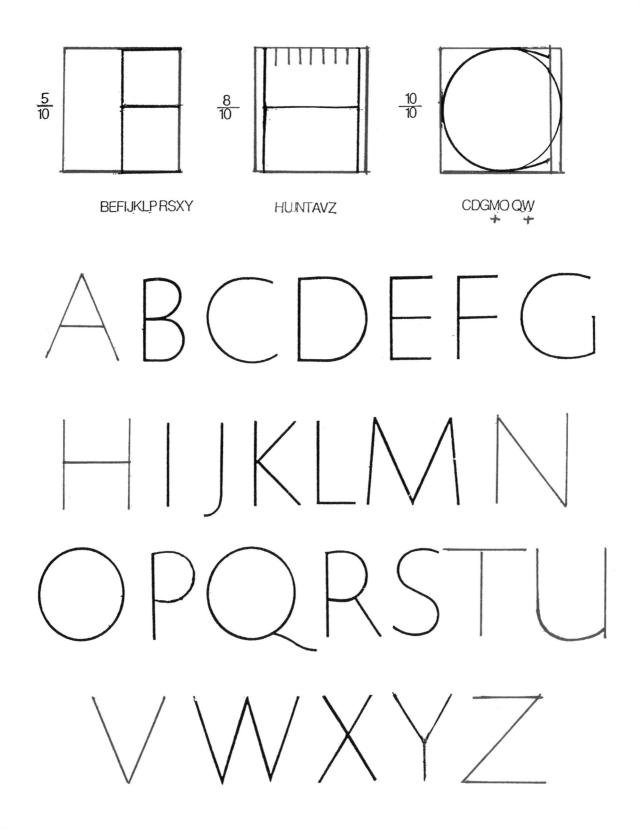

$\frac{5}{10}$ BEFIJKLP RSXY

$\frac{8}{10}$ HUNTAVZ

$\frac{10}{10}$ CDGMO QW

Above: The skeleton alphabet shown over a geometric framework demonstrates the relative proportions and underlying forms of Roman letters.

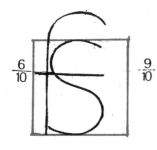
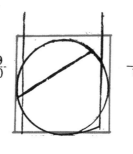
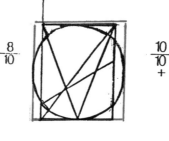
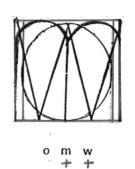

f k r s x b c d e g p q h u n t a v y z o m w

a b c d e f g

h i j k l m n

o p q r s t u

v w x y z

Above: The term Roman minuscule is a misnomer, as no
such alphabet existed. The foundational hand shown here
is a basic hand from which other lower-case forms derive.

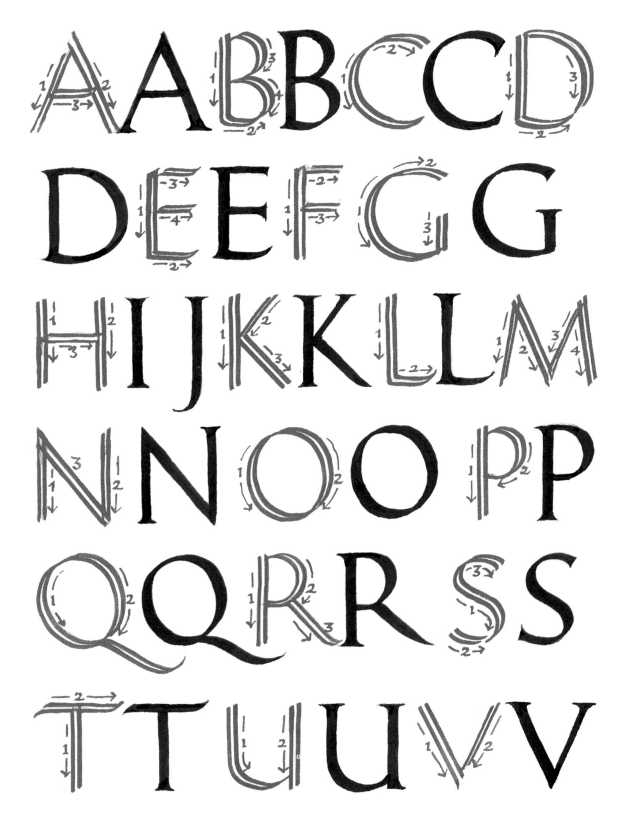

Above: The black letters show the orderliness of square

Roman capitals. The numbered strokes of the red capitals

show the pen movements and how to form the alphabet.

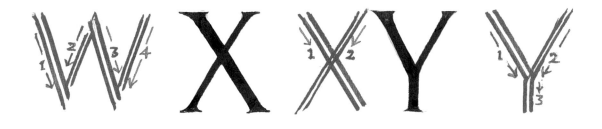

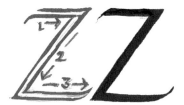

TRAJANS COLUMN

Above: Our alphabet today is based on classical Roman

letters. The most celebrated inscription of Roman capitals

appears on the Trajan Column in Rome, Italy.

UNCIALS

*Above: A detail showing half uncial
script, see the manuscript opposite.*

The bold, rounded forms of uncial letters create a
richly decorative texture that is appropriate to
modern graphic style, though uncials date back to
ancient Greek and Roman civilizations. The Roman
version developed as a cursive adaptation of square
capitals which was quicker to write. It became the
standard book hand of Christian scribes from the 5th
century to the 8th. Uncials are majuscule letters, as
can be seen in the even body height. But they have
begun to move away from the strict alignment of the
original square capitals in the development of short
ascenders and descenders applied to certain letters.
Notably, D, H and K look more like lower-case let-
ters and a similar conversion is occurring in P and Q;
although A and R remain distinctly capital forms.

The solidity of uncials derives from the horizontal
pen angle; the nib edge is held parallel to the writing
line. This creates a pronounced taper between thick
and thin strokes and a heavy vertical stress. Massed
uncials have an ornamental effect but high legibility.
Experiment with letter, word and line spacing to
create a heavily textured pattern or a clean, open lay-
out. The horizontal flow of the letters helps to unify
a line of writing and the vertical stress relates one
line to the next, even with generous spacing.

Half uncials are technically majuscules, but the
revised shapes of certain letters and standardization
of ascenders and descenders prefigure the minus-
cules that were the model for modern small-letter
shapes. The modification of uncial writing marks the
beginning of two distinct but complementary cate-
gories of letterforms, capital and small letters. The
most marked evolution of a letter is the change from
the angular capital A to a rounded form. It is easy to
see how writing at speed could simplify the con-
struction, reducing a triangular three-stroke letter to
a fluid, rounded two-stroke motion. Despite suggest-
ing the shape of things to come, half uncials still
have a lot in common with uncials. The boldness and
vertical stress dependent on the horizontal pen angle
remain, though the increased number of rounded
shapes and the outward flow of ascenders give the
script a less formal style. Slight hairline turns on hor-
izontal and diagonal strokes contribute a lighter,
livelier feel to the overall weighty texture.

This firm, clean script needs considered spacing,
particularly between lines, to accommodate the
length of ascenders and descenders. As there are no
distinct capital forms, half uncials can be combined
with uncials or with versal letters for emphasis.

Above: The Book of Kells is a beautifully written version of the Gospels. The half-uncials are balanced by deep line spacing that reveals developing ascenders and descenders on some letters.

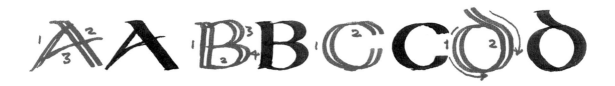

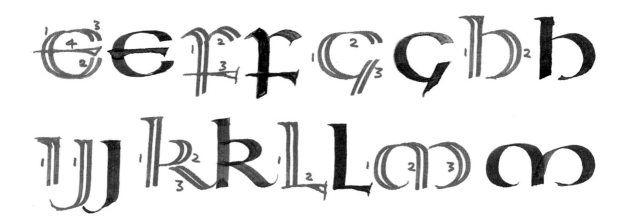

Above: The uncial alphabet. The pen angle, nib widths
height and serif formation are the same as for half uncials.

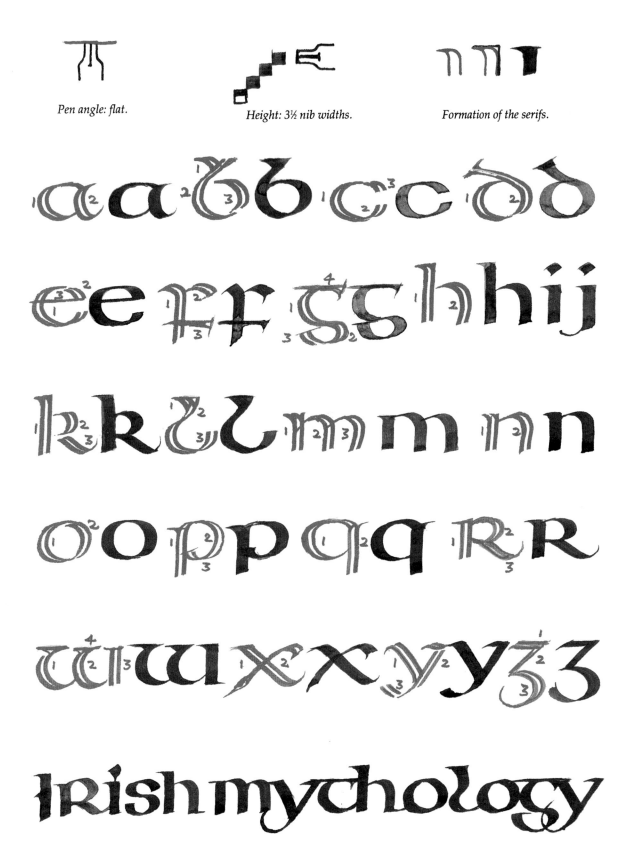

Pen angle: flat.

Height: 3½ nib widths.

Formation of the serifs.

Above: The half uncial alphabet in black. The numbered
red letters show how to form the strokes.

CAROLINE
MINUSCULE

Above: A detail showing Caroline
minuscule lettering, see opposite.

From the end of the 8th century a standard book hand was develped as part of an organized cultural reform throughout western Europe. The Carolingian or Caroline minuscule was devised by the monastic scholar Alcuin of York under commission from the Holy Roman Emperor, Charlemagne. The construction of all the letters was thoroughly considered and redesigned to produce a uniform, logical style. During the 9th and 10th centuries, the minuscule or small letter forms were not accompanied by a similarly revised majuscule or capital letter alphabet. Roman square capitals or uncials might be used, or highly elaborate decorated letters. In the alphabet sample shown overleaf, the lower-case letters are based on original Carolingian style and the capital alphabet is a modern construction modified from Roman square capitals to correspond to the less formal, fluid texture of the minuscules.

The circular O governs the broad, open forms and smoothly rounded arches and bowls. The emphasis is on vertical and curved forms and many of the small-letter constructions are comparatively simple, consisting of only two strokes. Three or four strokes are used where there is, for example, a cross-bar or curved descender to complete. The pen angle is 30° and the sample is written at four nib widths to height. As a rule of thumb, capitals are typically half as tall again as the lower-case body height and here six nib widths gives clean, stocky capital forms.

Slanted and curving strokes begin and end fluidly on the angle of the nib and can be pulled out into a tiny hairline flourish with a slight pen twist. Serifs for vertical strokes are started by pulling in from the left, but the vertical stroke is overlaid on the slanted serif strokes, to square the right-hand edge. Vertical stems and some slanted strokes also have distinct horizontal feet which give a firm base to the letters.

The script was designed to be highly legible and unambiguous. In particular, the capitals, based on classical proportions, read easily when joined into words and phrases. The combination of upper- and lower-case letters gives a firm, upright, open hand that reads clearly when applied to long texts. It is well suited to prose quotations and semi-formal pieces such as an invitation or inscription where neat styling and immediate legibility are important.

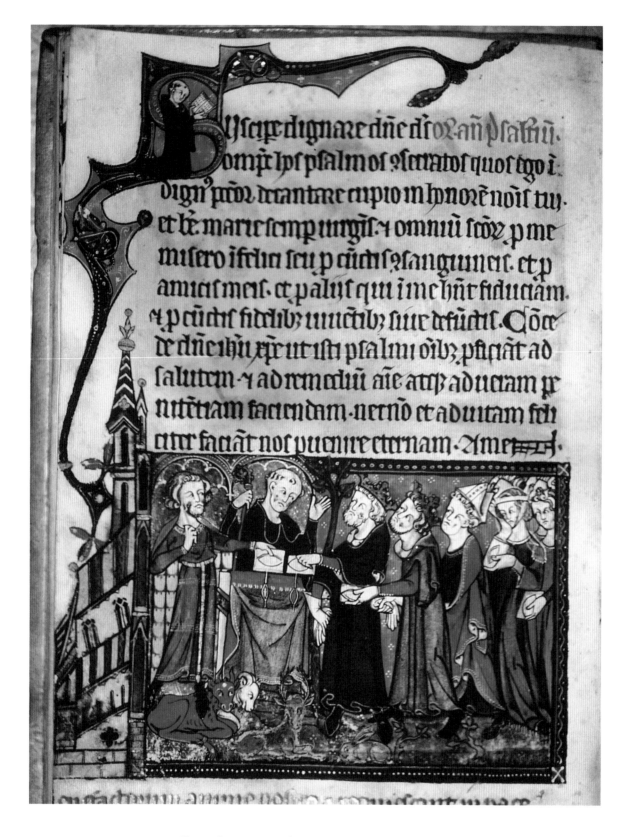

Above: The Ramsey Psalter was written in about AD 975 in

southern England, at either Winchester or Ramsey. It shows a

10th-century development from the Caroline minuscule .

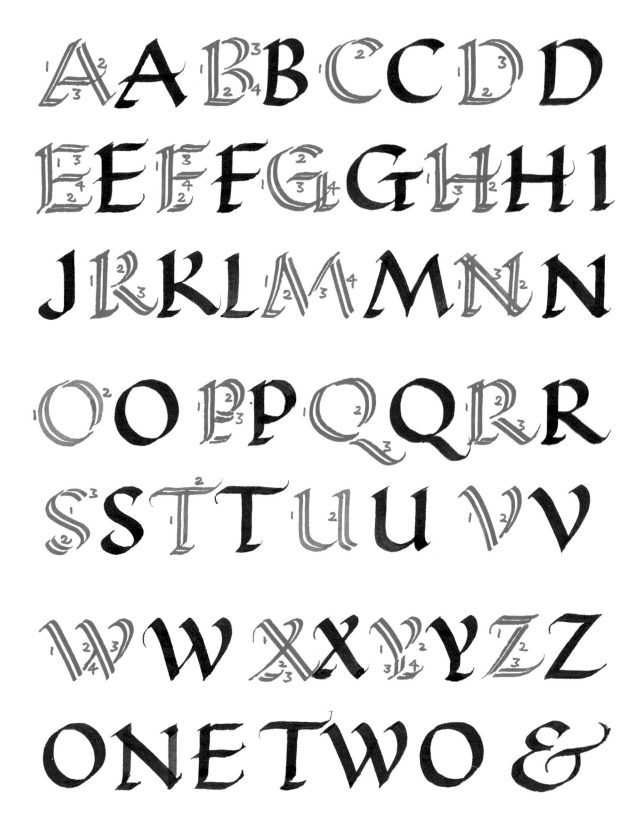

Above: The black letters show Caroline minuscule capitals
and the red strokes show the pen movements.

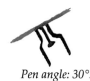

Pen angle: 30°.

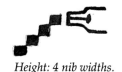

Height: 4 nib widths.

Formation of the serifs.

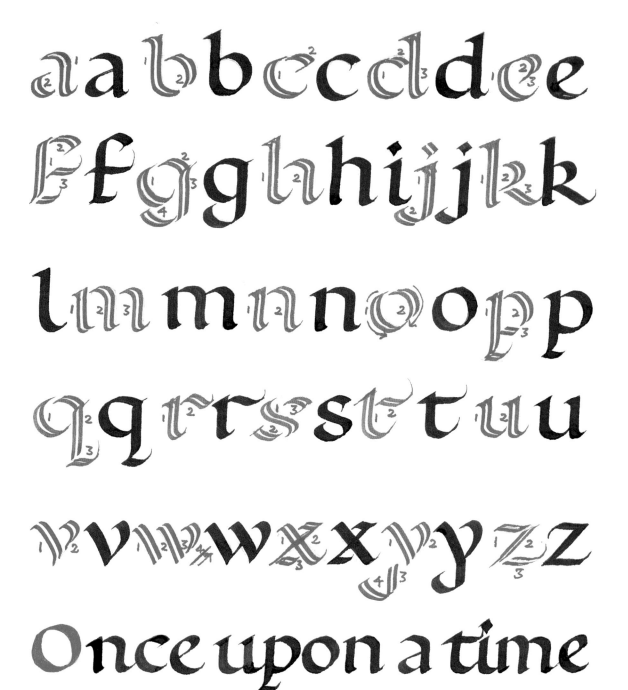

Above: The Caroline minuscule lower-case alphabet. The
numbered red letters show how to form the strokes.

COMPRESSED HAND

*Above: A detail showing the
compressed hand, see opposite.*

The compressed hand illustrates the tendency for a hand to become narrowed and compressed when scribes are writing at speed, a feature which is reflected in some of the 11th and 12th century modifications that followed the Carolingian minuscule. As a modern hand, it was developed by the English scribe Edward Johnston and his students in the early 20th century as a variation on the Foundational or round hand. The version shown overleaf also relates to italic writing, but maintains the open, upright influence of the 10th-century style, rather than the sharper branching of curves typical of italic.

The fundamental shape is the oval O, which is compressed as compared to the round hand but not so narrowly elliptical as in italic. Arches and bowls draw out from the main stems at a shallow angle and turn into generous, still quite rounded curves. With a 30° pen angle there is a marked but not completely abrupt transition from thick to thin in the curved strokes. The letterforms are quite slender but have clean, open counter spaces. Ascenders and descenders are extended, but they need to be well-proportioned. The way rising strokes turn over to

the right and tails curve or loop to the left gives a low-key "switchback" rhythm to joined letters. The compact body shapes of the lower-case forms, written at five nib widths to height, give a weighty, even texture that anchors the sense of movement.

In keeping with the character of a cursive style, the lettering has a slight tilt from the vertical. You may find it difficult at first to keep that element consistent, but it should be both uniform and subtle, or the joined letters will not have a regular flow.

In lower-case letters, main strokes that travel vertically, horizontally or on a slant can begin and end with a natural pen curve, occasionally twisted outward into a tiny flourish, as in t and z. Horizontal heads and tails are a lively feature of the capital forms, which help to create visual links between letters and words. These occur in H, I, J, K, T and Y as a balance to the vertical stress of the letter.

The characteristics shared with the rounded, Caroline minuscule make the compressed hand a highly legible and clear form, but it has a slightly more complex texture and a rhythm that lends itself attractively to modern graphics.

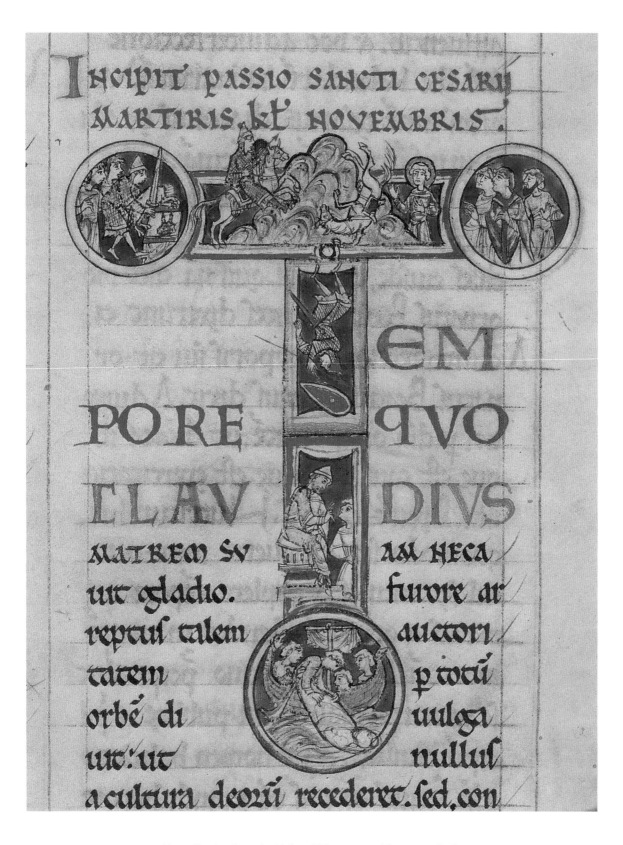

Above: Dating from the 11th or 12th century, this manuscript is a sample of the kind of scripts derived from Caroline minuscule (see page 40) that inspired the form of a modern compressed hand.

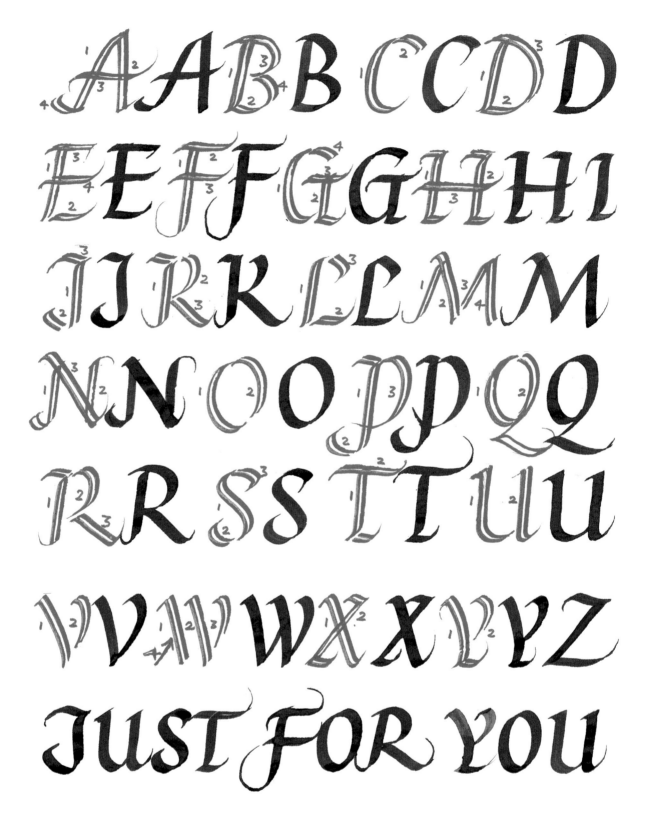

Above: The black letters show the capitals of compressed

hand; the red letters show how to form the strokes.

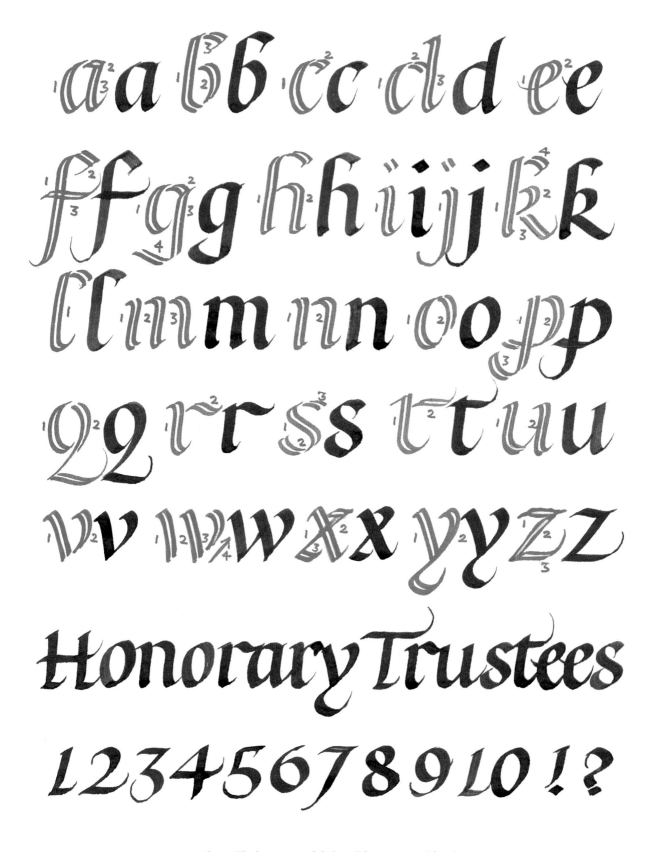

Above: The lower-case alphabet of the compressed hand;

the red letters show the pen movements.

BLACK LETTER

Above: A detail showing black letter,
see the manuscript opposite.

*T*he characteristic features of Gothic scripts are the relatively narrow proportions of the lower-case letters and the angular interpretation of curved shapes. Both elements appeared as variations in the Carolingian minuscule (see page 40) from as early as the 10th century in northern European countries. The evolution of style was gradual, but eventually resulted in the heavy, formal patterning of black letter, with its tight massing of strong vertical stresses. It is also known as "textura", meaning "web", which aptly describes how even and dense the texture can appear on the page.

The angularity came from writing rapidly and the horizontal compression allowed close spacing of letters and words, so for book scribes of the Gothic period, black letter was a practical and economical hand. In the most extreme form, textura was written with the interior spaces of the letters only the same width as the pen strokes. With the typically short ascenders and descenders, this produces a very rigid pattern that is difficult to read. In modern versions like the example shown here, the letters are more generously formed while preserving the essential flavor of the narrow, upright shapes. Historical black letter is represented by the lower-case alphabet.

There was no standard set of corresponding capitals. Uncials, versals and illuminated letters were often inserted in Gothic manuscripts for emphasis and to break up the texture. However, some examples of capital forms survive, to allow modern interpretations of the full alphabet. The black letter capitals overleaf complement the lower-case letters but are more fluidly developed, open shapes. The sample alphabets are written with a pen angle of 30° and the lower-case body-height is five nib widths. Capitals should be be disproportionately larger; at seven nib widths their shapes are controllable, not over-extended or slack on the curves, and consistent with the small letters. Serifs are small lozenge shapes created with a slanted pull of the pen. They are positioned slightly off-center at the top or bottom of main strokes. The even weight of black letter can be offset in both upper and lower-case forms by fine hairlines that extend from or cross main strokes. Although the style should be fairly regimented, tiny flourishes give life to the texture.

A specially singular form in the lower-case alphabet is the letter x. It is not made with crossing strokes, but with a main stem designed in keeping with the vertical emphasis of other letters.

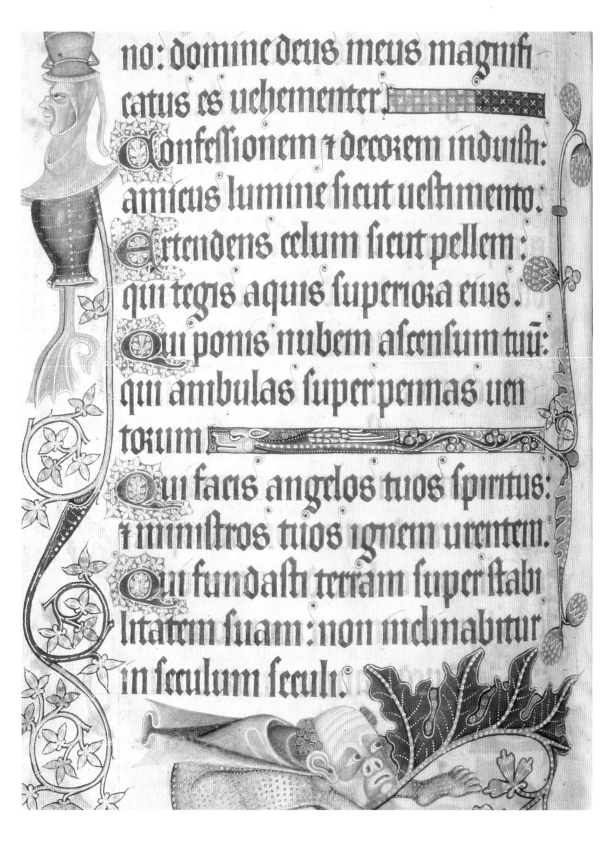

no: domine deus meus magnifi
catus es uehementer.
Confessionem ꝝ decorem induisti:
amictus lumine sicut uestimento:
Extendens celum sicut pellem:
qui tegis aquis superiora eius.
Qui ponis nubem ascensum tuū:
qui ambulas super pennas uen
torum
Qui facis angelos tuos spiritus:
ꝝ ministros tuos ignem urentem.
Qui fundasti terram super stabi
litatem suam: non inclinabitur
in seculum seculi.

*Above: The Luttrell Psalter was named for Sir Geoffrey Luttrell
who commissioned it in about 1335. The angular Gothic script in
this finely decorated English manuscript is clean and legible.*

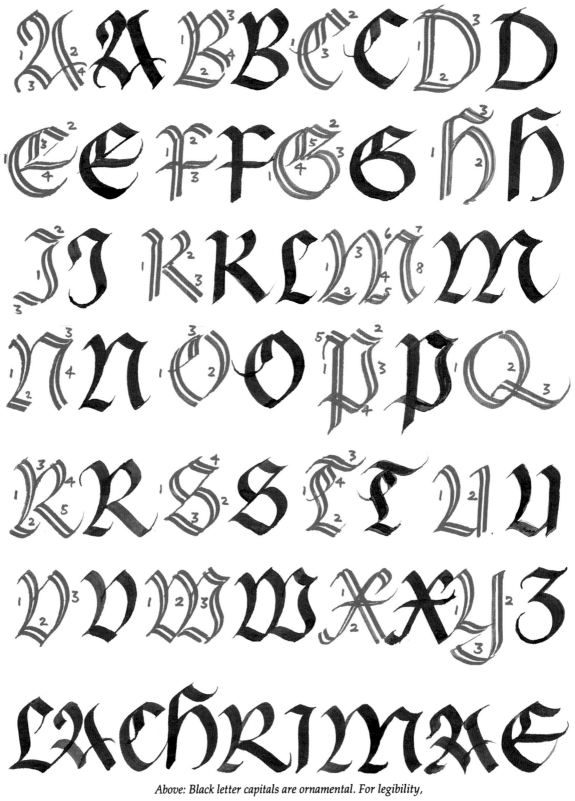

*Above: Black letter capitals are ornamental. For legibility,
combine upper and lower-case letters. The red letters with
numbered strokes show how to form the alphabet.*

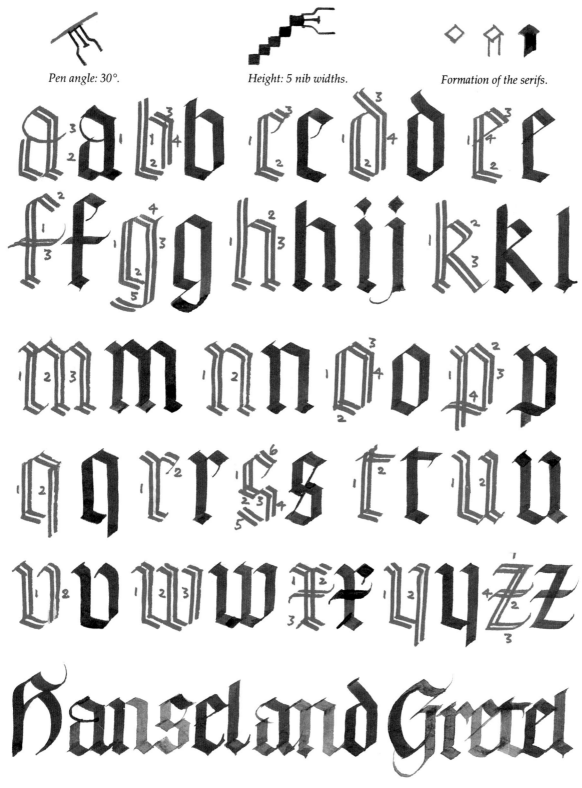

Pen angle: 30°.

Height: 5 nib widths.

Formation of the serifs.

Above: Historical black letter is represented by the lower-case alphabet. The red letters with the numbered strokes show the order of pen movements.

GOTHIC CURSIVE

*Above: A detail showing Gothic
cursive script, see opposite.*

A number of informal cursive writing styles developed out of the regimented Gothic lettering. The natural flow of a cursive, or running hand, encourages more rounded letters and occasional slanting, as in the alphabet sample shown overleaf, although it still has the compactness and angularity of earlier Gothic shapes.

A new influence on the letter shapes is the pointed, ogee O. This is an eastern design element that was introduced to Europe by travellers returning from the Middle East. The capital letter O has swelling "minaret" curves flowing from a pointed tip. In the more compact lower-case form, the o appears as a smoother tear drop shape.

Letters with slanted strokes, like V and W, are constructed with shallow, dancing curves rather than formal straight lines. The rhythmic pattern of cursive writing is very pronounced and both upper- and lower-case alphabets have a graceful, ornamental quality with an oriental feel. The pointed arches and bowls prefigure italic style.

Holding the pen at 45° to the writing line automatically creates abrupt thick-thin variations, and a compact ratio of three-and-a-half nib widths to height makes the lower-case alphabet well-textured.

Five nib widths makes a reasonable proportion for capitals. However, all proportions can be adjusted, say, by half or one nib width, depending on how open you want the letter shapes to be.

Serifs are natural pen hooks following the writing angle, leading into and out of the strokes. The pen angle also creates the tapered, short descenders of lower-case f, p and q. By contrast, the ascenders on d, h and k are elaborated with a short arching stroke to the right and variously curved or angled. Small downward hooks and flourishes are characteristic in the capital letters. The abbreviated curve breaking vertically in the bowl of C, E, G, O, Q and T is part of the style, whereas hairline extensions to main strokes are optional and involve twisting the pen onto the corner of the nib to obtain a very fine travelling line. The hairlines contrast with the denser texture of curved and angled main strokes and subtly link the letters as they are joined into words.

With both capital and lower-case forms, spacing in between letters needs to be quite close, to develop the continuous rhythm of a cursive hand. Joined capitals make a richly decorative texture suitable for short titles or headlines. This is a highly legible script with a slightly exotic character.

Above: A 15th-century French book of hours made for Margaret de Foix. Books of hours, personalized prayer-books for private devotional use throughout the day, were often beautifully orna-mented like this with pictorial miniatures and colorful patterns.

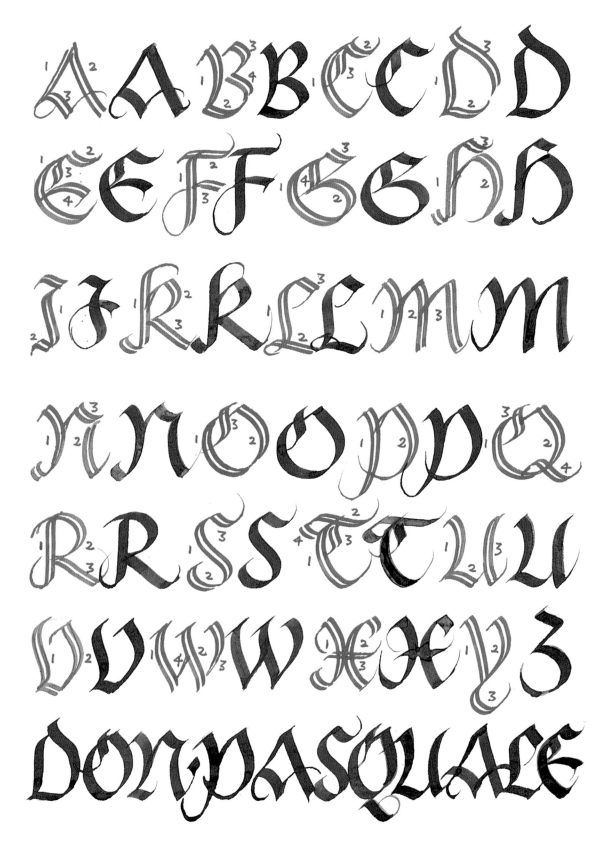

*Above: The numbered strokes of the red capitals show how
to form the decorative Gothic cursive alphabet.*

Pen angle: 45°.

Height: 3½ nib widths.

Formation of the serifs.

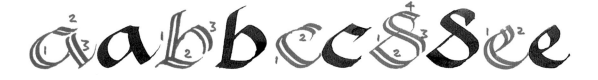

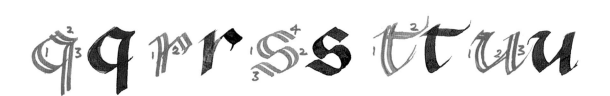

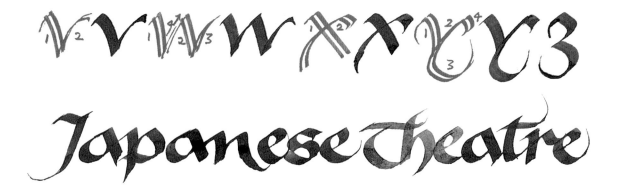

Above: The red letters with the numbered strokes show
how to form the lower-case Gothic cursive alphabet.

ROTUNDA

Above: A detail showing Rotunda
lettering, see the manuscript opposite.

The Gothic scripts of southern Europe were not as rigid or compressed as the northern styles. Rotunda is a rounder, more open hand associated with formal writing in 15th-century Italy and Spain. Although it retains a degree of angularity, the letter shapes are relatively expansive and uncluttered, in keeping with the temperament and cultural background of the Mediterranean regions. A humanistic period was beginning in which scholars looked back to rounded classical shapes, and certain letter formations also bear the mark of 10th-century influence, reflecting the orderly forms of Caroline minuscule.

The style is characterized by firm shapes and weighty curves which the pen movement makes slightly pointed in relation to thick-thin turns. The typical Gothic emphasis is vertical, loosened by the broader shapes which help to provide a horizontal balance. There are short ascenders and descenders and minimal elaboration of heads and tails.

The circular o and the arches and bowls of lower-case forms are slightly squared; m and n are the most severely angular, and more reminiscent of black letter than, say b, d, p and q. Occasionally very fine strokes are needed to complete a letter construction, represented in the looped-over curve of a, the cross-bar of e and the joining stroke linking the bowls and tail of g. Serifs leading into main strokes in lower-case forms show the merest shift of the pen that gives a slanted start to the vertical. The feet of vertical stems and the short descenders are finished cleanly and abruptly on the pen angle, which is 30°. The sample overleaf is written at four nib widths to height, giving compact, medium-weight letters which are opened up by the curving counter spaces.

Capitals show more of the rounded emphasis of basic shapes. A height of six nib widths creates strongly formed letters of an appropriate size and weight to go with the lower-case forms. In keeping with the style, the forms are sturdy and clean, using essential construction features so that each letter can be recognized unambiguously, but avoid any purely formal decoration to the basic style.

Capitals were not always standard in manuscripts of the time, though there were examples from which the modern calligraphic styles have been derived. Rotunda minuscules were also teamed with colorful versals that acted as the capital forms. The script and accompanying illuminated letters were often used in musical notation, as text lines running alternately with staves and notes.

Above: The generous, beautifully legible rotunda script creates a calm area of the page suited to the contemplative nature of the text in this spread from the Serristori Book of Hours. Paragraphs and sentences are ordered against colored versal letters.

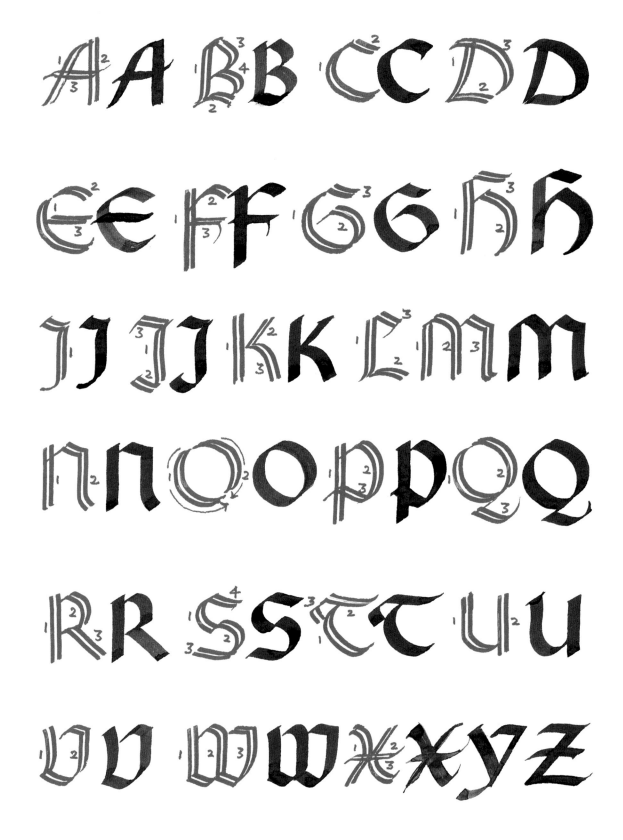

Above: The black letters show the rotunda capitals. The red letters with the numbered strokes demonstrate the pen movements and show how to form the individual strokes.

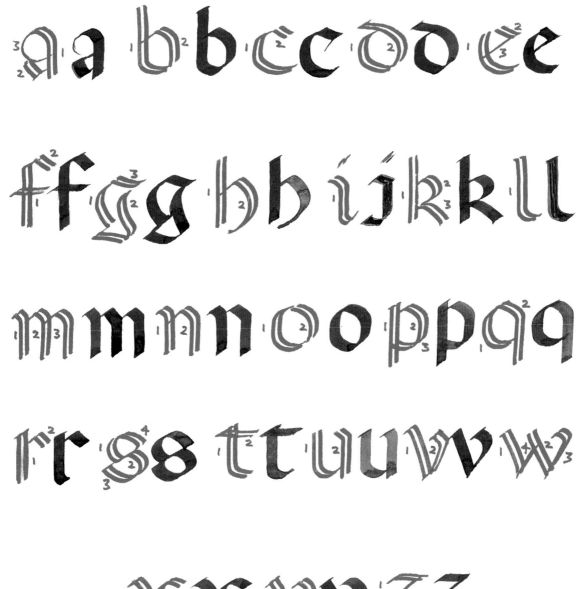

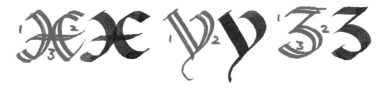

*Above: The lower-case rotunda alphabet. The red letters
with the numbered strokes show the pen movements and
demonstrate how to form the individual strokes.*

ITALIC

*Above: A detail showing italic script,
see the manuscript opposite.*

The elegant, flowing letterforms of italic were developed by Italian Renaissance scholars. Interest in the classical world led them back to antique inscriptions and manuscripts and the texts that they were studying had often been copied out in Carolingian minuscule by earlier scribes. The styles of these historical documents influenced Renaissance writing, as did the rhythmic, informal pattern of Gothic cursive (see page 52). The combination of influences resulted in the practical styling of italic, which evolved as a clean, highly legible script that could be written at speed.

Italics had a modernist feel that has been easily updated. In the 20th century the Renaissance letterforms have provided models for both formal calligraphy and informal handwriting styles. Italic is a very popular script that adapts well to all kinds of subjects for calligraphic design, equally effective as large-scale display writing or small-scale block text.

The essential characteristic of italic is the elliptical O, which is echoed in the branching arches and curves and governs the compressed, slender proportions of all the letters. Italics are usually written with a uniform slant to the right. The slope is not exaggerated, but gives the lettering movement and fluidity.

In the alphabet sample overleaf, you may notice that the diagonal strokes have a hint of a curve, which avoids a too-rigid pattern emerging when letters are assembled into words. The almost hairline serifs are formed by a slanting pen-pull which hooks over easily into the thick strokes, and a corresponding slant pulling out at the bottom of a stem. Ascenders, descenders and horizontal strokes taper along the line of pen movement, with a gentle flourish.

The height of capitals is seven nib widths and the body-height of lower-case letters is five nib widths. Ascenders are subtly elongated to give an elegant, slender feel to the alphabet, but they should not appear exaggerated. Ascenders and descenders are in general a little shorter than body-height.

Interior spaces remain clean and open, despite the narrowed, elliptical curves. This is important as italic writing has a fairly even, dense texture and needs to have a good balance of tone. You need to keep that in mind when planning the spacing of a long text. Because the letters are compressed, large spaces between words or lines will make them seem separate and disconnected, but if the lettering is too crowded, the rhythmic emphasis of the slanted script may interfere with legibility.

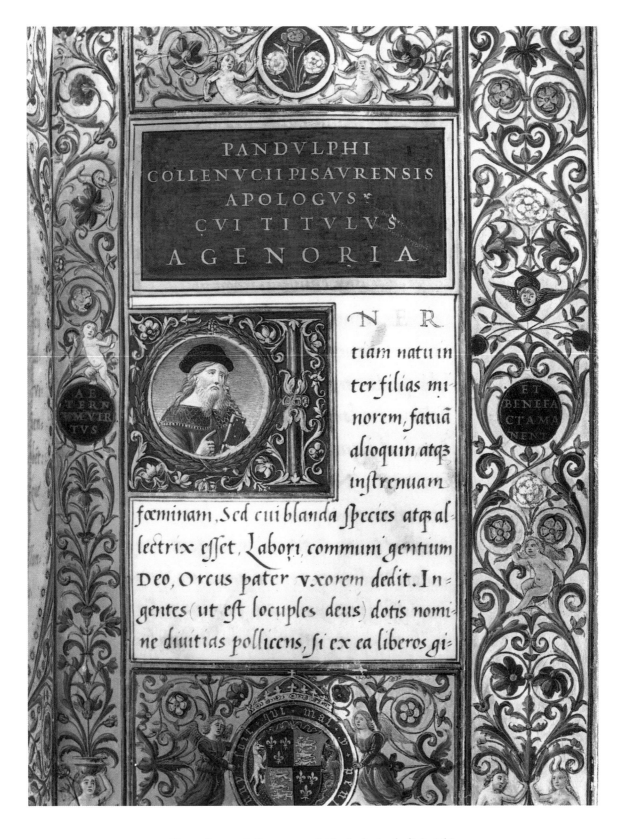

PANDVLPHI
COLLENVCII PISAVRENSIS
APOLOGVS
CVI TITVLVS
AGENORIA

N ER
tiam natu in
ter filias mi
norem, fatuã
alioquin atqz
instrenuam

fœminam, Sed cui blanda species atqz al
lectrix esset, Labori communi gentium
Deo, Orcus pater vxorem dedit. In=
gentes (ut est locuples deus) dotis nomi
ne diuitias pollicens, si ex ea liberos gi=

Above: A presentation manuscript by Ludovico degli Arrighi, a
16th-century scribe employed in the Apostolic Chancery in Rome.
The oval O and branching curves are typical of italic.

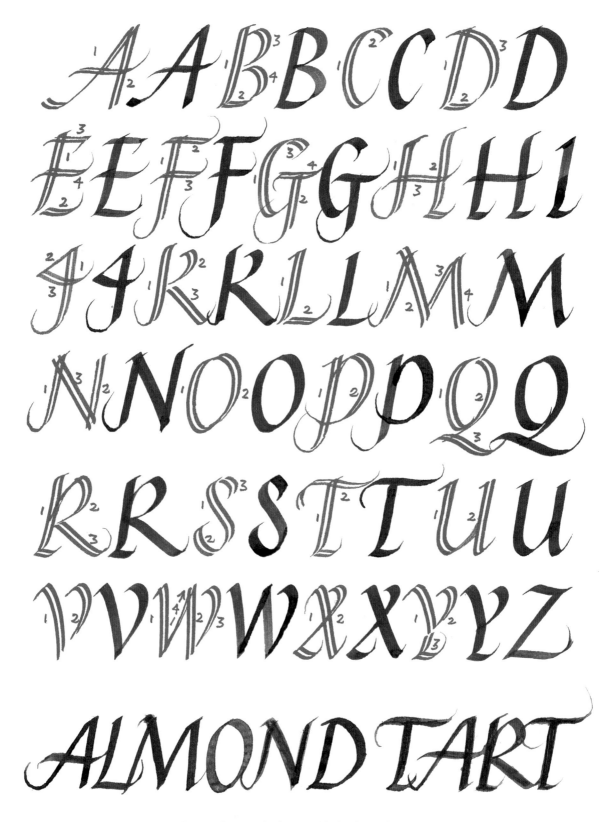

Above: Italic capitals shown in black. The red letters show

the pen movements and how to form the strokes.

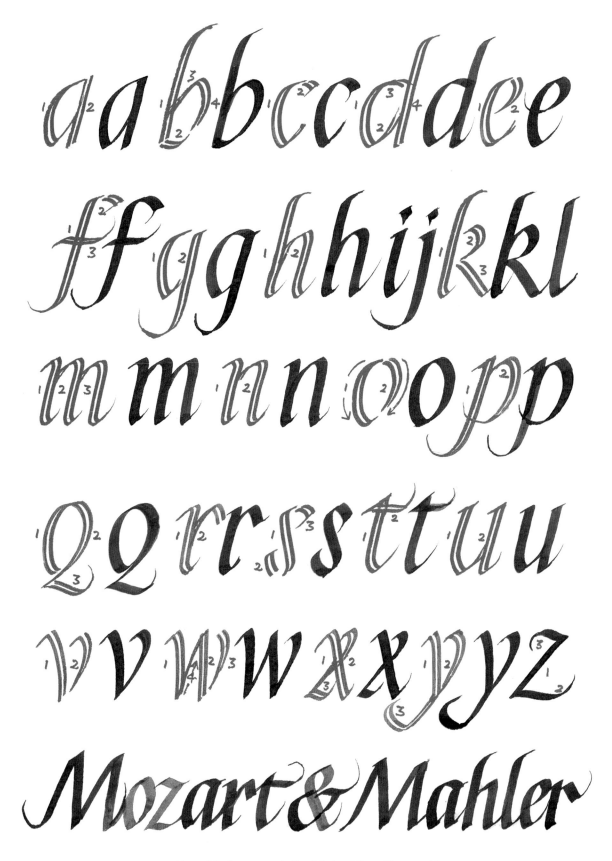

Above: The lower-case italic alphabet. The red letters with numbered strokes show how to form the letters.

MODERN CURSIVE

*Above: A detail showing modern
cursive, see the manuscript opposite.*

Cursiveness is the characteristic of ordinary handwriting, the flow and speed that makes the letters travel easily and join freely. A cursive calligraphic script is generally more considered and elegantly styled than handwriting. The techniques of pulling the pen, making pen lifts and following a logical order of strokes still influence the shaping of the letters, but with less formality than for, say, the rounded uncial letters or the angular black letter.

As new styles of writing were introduced throughout history, cursive forms would develop out of the scribes' own methods and the context of the work. The same is true for present-day calligraphers, particulary as freedom, energy and rhythm are especially pleasing to the modern eye and complement the broader context of inventive graphic design. When you have mastered the basic alphabet styles previously demonstrated, you will be equipped to begin to explore variations on your own, referring to standard forms for inspiration.

The alphabet overleaf is one that the calligrapher has developed, freely incorporating elements of italic and Gothic cursive. Basic features to note are the elliptical O, from italic, the branching of arches and bowls and the gentle slant to the letters.

Try to capture the rhythm of the curving ascenders and descenders and the looped and flourished finishing strokes. These contribute to an active pattern when the letters are joined, as do the sometimes elongated pen hooks leading into and out of main strokes in the lower-case letters. Extended terminals appear in the capital forms but crossed and slanted strokes are often pulled out into hairlines, though the tail of R ends cleanly on the angle of the nib.

When using the alphabet sample as a copysheet, try to work quite rapidly and spontaneously, using the rules of order and direction of strokes that you have learned from the more formal styles to help you construct the letters. You can adapt this kind of cursive lettering informally but do not abandon the consistency of related forms. For example, the way the elliptical O governs the compression of counters and bowls and the formation of arched letters.

As you start to make freer interpretations like this in your calligraphy, you can experiment with numerals, symbols and punctuation marks in corresponding style, as shown overleaf. If you join letters into script, consider how parts of the letter constructions serve as linking devices that emphasize the flow of words and give texture to the whole.

Nec male corrctat . Quis em tam nudus sit illū
Bis fcrat? ct crusar pucro si 3 tigit aurcuz
Vel nodus tm 2 signū dc paupe loco
Spes bn cenandi nos decipit : ccce dabit iaz
Semesum leporez : atqz de clumbj apri
Ad nos iam venit / minor altilis unde pazato
Intacto qz omnes 2 steteto pane tacetis .
Ille sapit qui te sic utitur . ¶ Oīa fere
Si iuxtes 2 debes : pullandū uctua kalo
Przebebis qneqz caput : nec dura timebis
flagra pati; his epulis 2 tali dignus amico .

SATIRA VI .

Rrcdo pudicitiā satūno rege mozatā
In tris uisam qz diu cū frigida puas
pbet speluca domos igne qz larem qz
Et pecus; 2 dnos com claudet ubra .
Silucstre motana thorū cū stcret uxor
frodibz 2 culmo; uininarcuz qz fcras
Pcllibz; haud similis tibi ānthia; ne tibi cuius
Turbauit nitidos extictus passer occllos
Sz potanda fcres infantibz ubera magnus
Et sepe occidior grandem ructate maruto
Quippe alit tūc orbe nouo celo qz recti
Viucbāt hoīes; qui ruptā roboce nati
Composit qz luto nullos huece pactes

*Above: This attractively spiky, informal semigothic cursive could
provide an interesting starting point for a modern interpretation.
The piece is part of a text by Juvenal, probably copied by a scholar
for personal use, hence the margin annotation.*

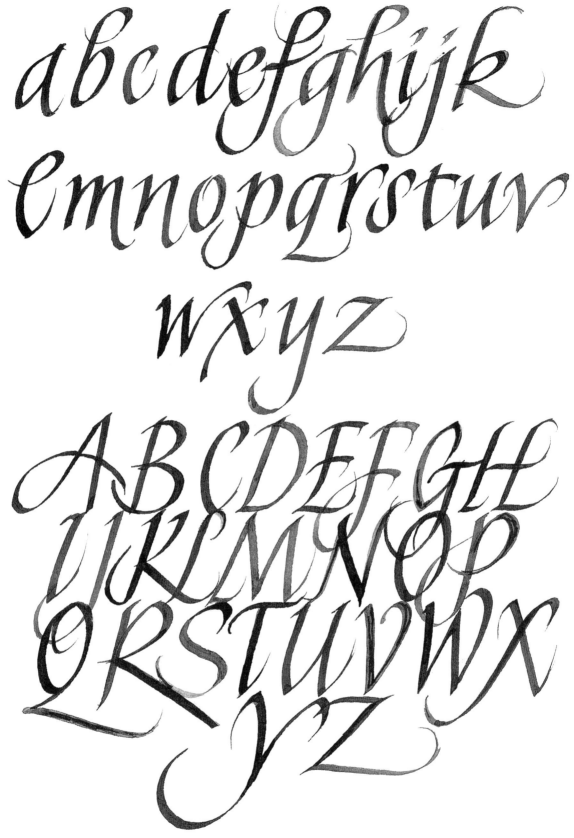

*Above: The lower-case and upper-case alpabets of modern
cursive have a flowing, informal quality.*

1 2 3 4 5 6 7 8 9 10 :.

& & & & &

& & & & &

? ? ? ? "oh" ! ! ! ()

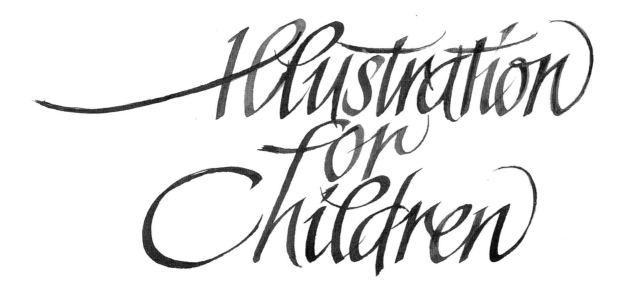

Above: Modern cursive combines elements of Gothic style

with a more open, curvaceous style of writing.

COPPERPLATE

Above: A detail showing copperplate,
see the manuscript opposite.

*A*s a form of calligraphy, this is quite different in kind from the preceding styles. The texture of copperplate lettering, also called "roundhand", does not depend on the fixed angle of an edged pen, but on varying pressure applied to a pointed nib. A light touch produces a fine line; increasing pressure splays the nib, causing the pen stroke to swell.

From the 16th century, printing from type blocks took over the work formerly done by copyists and scribes. Some scribes became writing masters and served an increasingly literate population. They developed varied, sometimes highly elaborate styles and published copybooks and writing manuals to show off their skills. The lettering for these books was reproduced by engraving on copper. The engraver's burin, a tool used for fine drawing and line ornamentation on metal, in turn modified the style of the pen letters. The features naturally created by the edged pen were lost. Copybook hands became finer and fluidly rounded, looped or flourished, and could be written with fewer pen lifts.

Copperplate has a pronounced slant and is often written with a "swan-neck" nib which has an angled shaft, which enables the calligrapher to hold the pen comfortably while achieving the angle.

You can also work with a straight pen and turn the paper if necessary to accommodate the writing slant, or even with a fine-pointed brush that responds to pressure in the same way as a flexible nib. To keep a consistent slant, rule a grid on your paper with lines crossing the horizontal writing lines at 60°.

The sample alphabet overleaf shows a modern interpretation based on various sources and many of the letters are written in a continuous motion, like ordinary handwriting. You need a second stroke in certain letterforms with bowls, loops, tails or crossbars, but mostly the constructions flow more directly than in edged-pen styles. Curves are looped and not branched or angular; it may help to imagine a small circle at the top or base of the letter, on which the pen travels around the shape.

Because of the fineness of copperplate and the subtle swell and taper, it may take you a while to get a rhythm for clean, well-proportioned letters. With a pointed pen you do not have a given weight ratio of nib widths to height, but do not make the letters too tall or they will look spindly and uneven. For elaborate copperplate styles look out for the work of writing masters such as Edward Cocker, John Ayres, George Shelley, Charles Snell or George Bickham.

and

Mr John C

Gentlemen,

Tho' J hazard the Loſs of Yoʳ Favour by

J cannot Omit ij Opportunity of letti

Retain a Grateful Remembrance, of t

Genteel Treatment, J met w.ᵗʰ in my Te

They're such Gentlemen as yoʳ Selves ij

to whome ij World's oblig'd for all ij Adv

Above: This elaborately flourished copperplate sample is the work
of the writing master George Shelley. It dates from about 1710
and is designed to demonstrate presentation and layout for
formal correspondence, as well as the style of the hand.

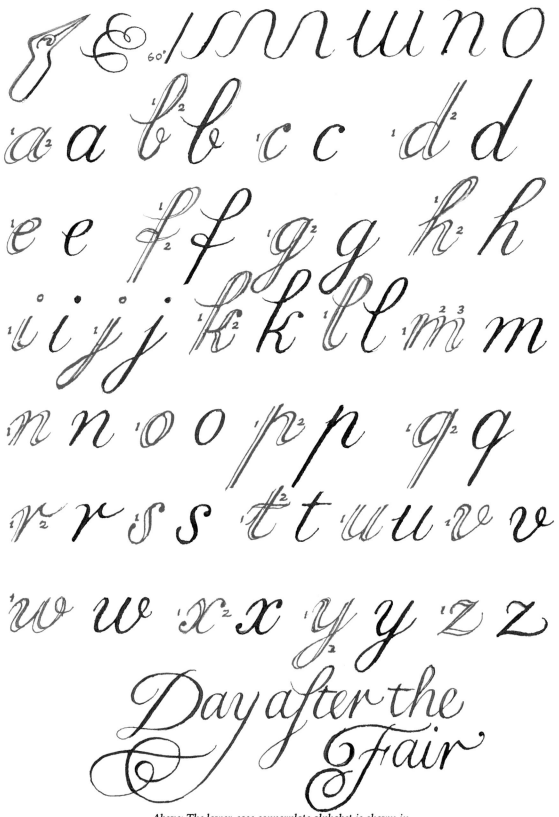

*Above: The lower-case copperplate alphabet is shown in
black letters. The red letters with numbered strokes show
the pen movements and how to form the strokes.*

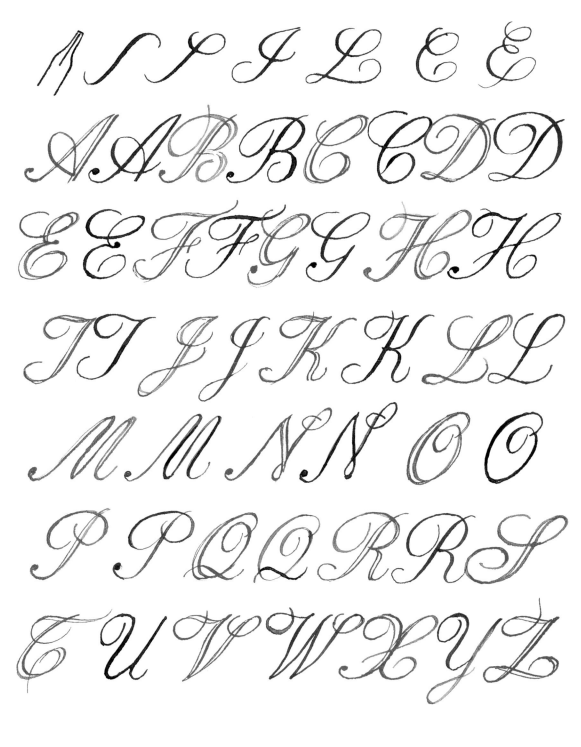

Above: The upper-case copperplate alphabet is highly

ornamental. It is characterized by elaborate flourishes and

loops. Use the template above to practice the letters.

VERSALS

Above: A detail showing versals, see the manuscript opposite.

Versals are large capital letters that were used in manuscripts to give emphasis to parts of a text, at the start of a chapter, paragraph or verse, for example. As a decorative feature, they were often written in color to contrast with black script. There is no lower-case form of versals, but the capitals combine well with uncials, half-uncials or the Caroline minuscule. Two basic versal forms are recognized; an early version based on square Roman capitals, which is relatively austere, and a Lombardic later form developed in Italy, in which the letterforms are swollen and curvaceous, deriving from uncials.

The essential difference between versal letters and other alphabet styles is that they are constructed letterforms with compound strokes. The thickness of a stem is created by drawing an outer and inner stroke and then filling the center with another stroke of the pen. Slanted strokes are similarly formed. In letters with bowls and curves, the inner edge of the curve is defined first, then the outer, and the center filled in. Alternatively, the center stroke can be omitted, so the forms are presented as outline letters.

Ink is too free-flowing to construct versals clearly and it is best to use watercolor paint or gouache, diluted to a fine but slightly creamy consistency.

This results in a slightly raised effect when the paint has dried, giving additional weight and texture to each letter. You need to use a narrow, flexible nib with a long slit in the tip. For vertical and slanted strokes the pen is held at right angles to the writing line. Vertical stems are drawn slightly "waisted", or concave in the middle. For cross strokes, which are flared, the nib is held horizontally. The serifs are hairlines crossing the main stroke at a right angle. In curved strokes, the inner curve is flattened and the outer curve swells, creating a thick-thin taper.

The Lombardic versals are relatively ornate, with exaggerated curves and more pronounced flaring. Once you have mastered the construction of either type of versal, you can experiment with them as decorated letters. For example, filling the center with a different color from that used to outline the shapes, or incorporating small pattern motifs within the thickness of main strokes. In old manuscripts, versals were also elaborated with illustration, often using plant and animal motifs. There is no fixed proportion of weight to height or thick-thin variation, so versals lend themselves to free design. When you start to combine letters into words and phrases, you can play with size and spacing, as shown overleaf.

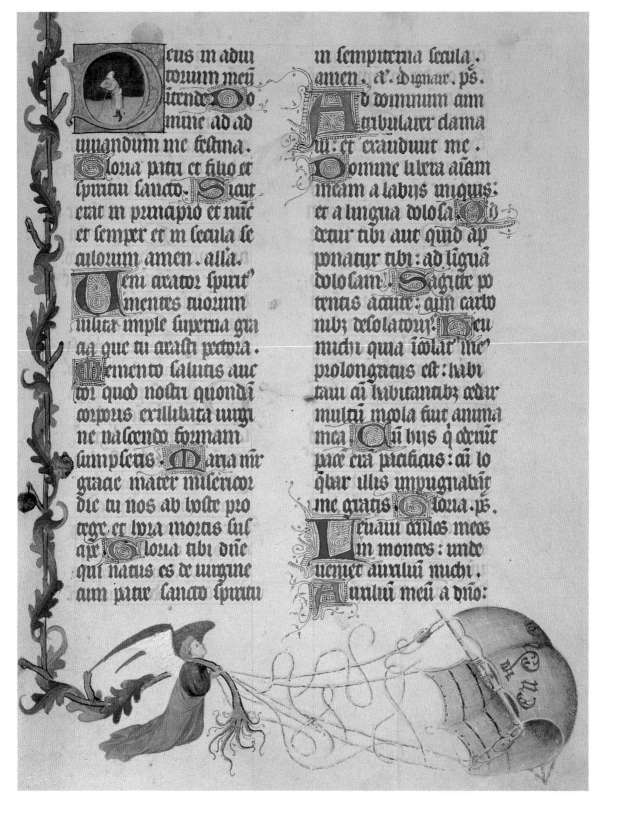

*Above: In this 11th-century text known as the Egerton
Manuscript, the colorful versal letters in varying sizes make a
form of rhythmic punctuation through the script.*

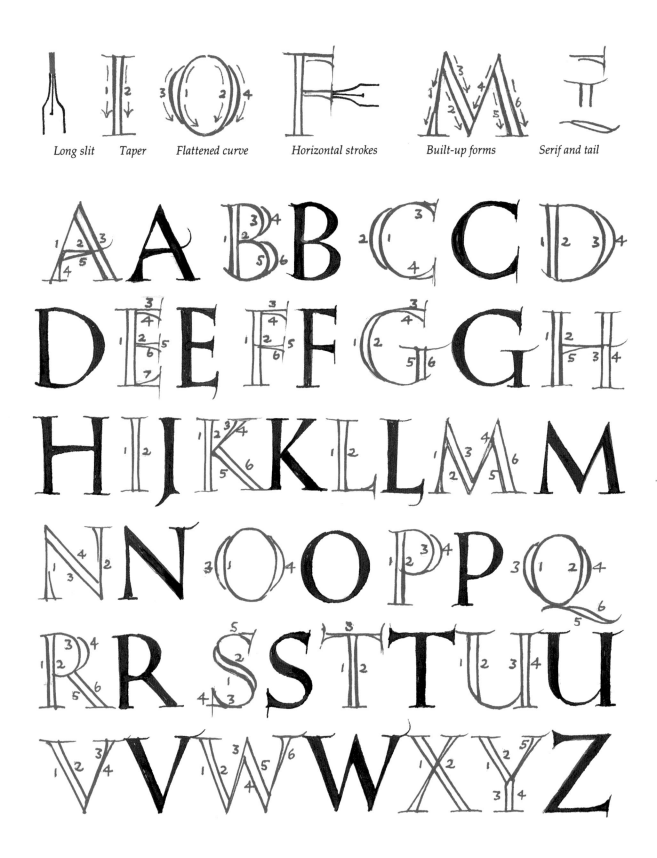

Long slit Taper Flattened curve Horizontal strokes Built-up forms Serif and tail

Above: The black capitals show standard versals; the red

skeleton forms show how to form the strokes.

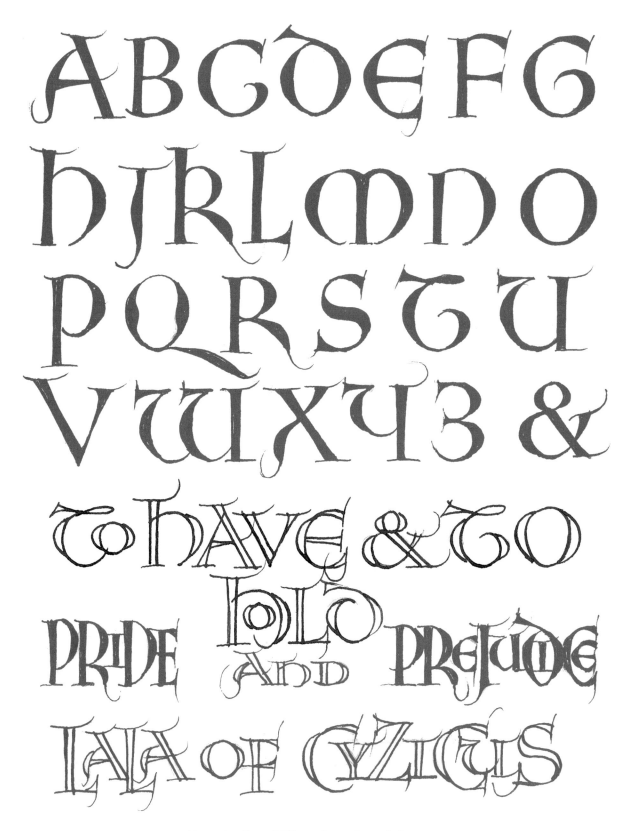

*Above: A gallery of different forms of versals that you can
adopt to embellish blocks of calligraphy.*

Gallery

CARD DESIGN

*F*inely crafted calligraphy makes a beautiful image for all kinds of greetings cards. By designing and scripting your own cards you can create a traditional message delivered with personalized impact. Card design is a simple way to start using your lettering skills effectively. Choose the form of words for the greeting and an alphabet style that you enjoy, and experiment with different ways of combining these basic elements. As well as varying the layout of the words, try different nib widths and letter heights that alter the weight and rhythm of the calligraphy.

Above: A horizontally flowing line based on the modern cursive alphabet is balanced with elegantly curved, long descenders.
Right: In a centered, vertical arrangement, the large capitals and looped tails give a more open feel.

Right: Variation of the pen angle gives more emphatic thick and thin contrast.

Happy Christmas

Happy Christmas

Above: Even-textured, heavy writing "hangs" beneath the extended cross-bar of the initial H.
Left: Lower-case letters written in pale tone with a broad automatic pen, with colors dropped in while the strokes were still wet.

Christmas

Left: Generously flourished capitals make strong but legible shapes.

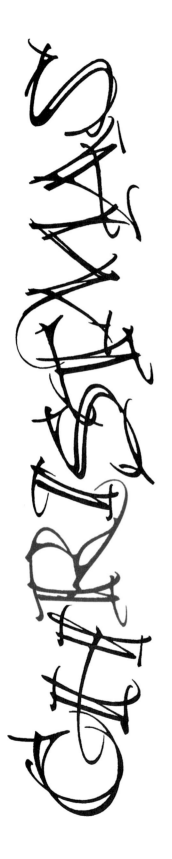

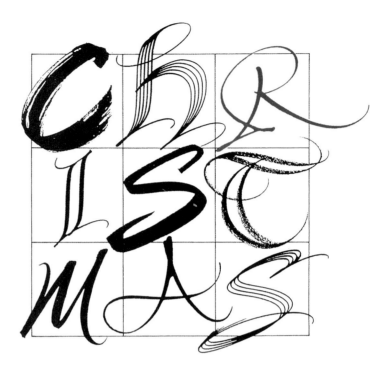

One of the elements that you can experiment with is the actual form of the card. A square is less usual than an upright or horiztontal rectangle, but the compactness of the shape can be exploited with a careful balance of words or lines. As an alternative, you can break down the message visually.

Top: Letters treated individually within a grid.
Left: A lively interpretation of versal letters.

You can apply different treatments to individual letters, or groups of letters. Some kind of order or connection may be needed to re-establish a link between them, such as a grid framework, flourished loops or background color. In the square-format card opposite the contrasting letters in the word Christmas are contained in an orderly grid. An elongated layout can be effective whether designed vertically or horizontally; as a practical point, consider how the card format will fit into an envelope.

Above and far right:
The loop of Y forms a
base for fine writing.
Opposite: Loops and
tails make flowing
links through these
compressed capitals.

Top and left:
Slanted and close-
fitting letters work
well in both a slim
positive form (top)
and a broader nega-
tive form (left).

LOGOS

To create your own logo, a company or a product name is an opportunity to give words a real character of their own. As these examples show, in a successful logo the shapes and textures have a strong abstract quality, whether the lettering is conventionally styled or freely developed.

The powerful visual impact of black and white contrast holds its own when you exploit fine line qualities, thus giving energy to angles and curves. But keep in mind that the thickest strokes also need to be enlivened by the motion of the pen, and the heaviest black can still describe an active shape.

Right: A change of weight between the top and bottom line of lettering subtly enhances this simple lower-case style.

Above and right: A very broad pen nib that is twisted and turned onto its corner produces these dancing loops.

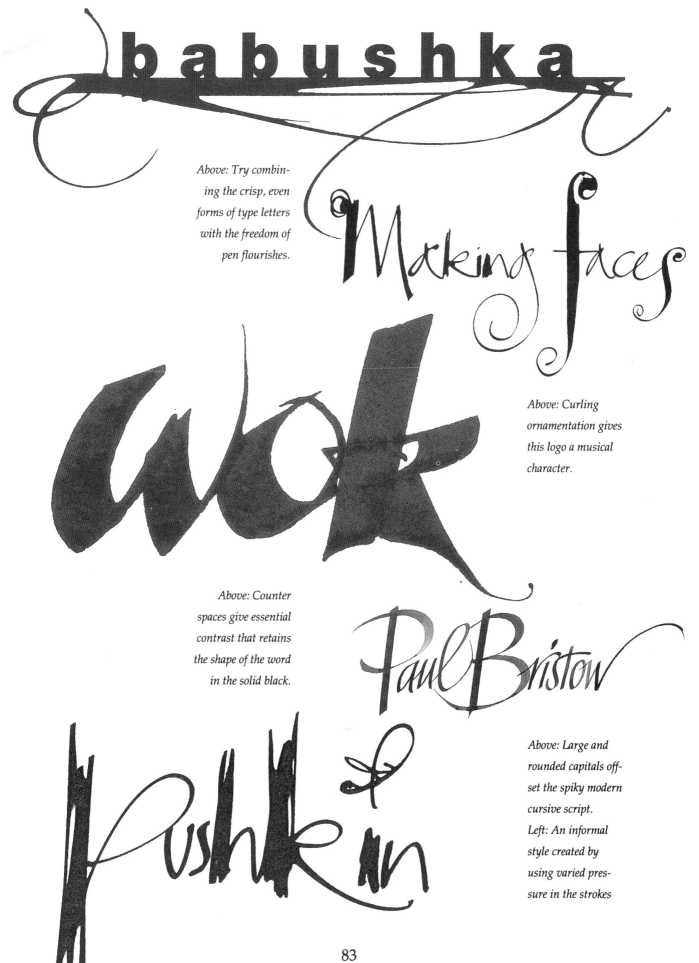

Above: Try combining the crisp, even forms of type letters with the freedom of pen flourishes.

Above: Curling ornamentation gives this logo a musical character.

Above: Counter spaces give essential contrast that retains the shape of the word in the solid black.

Above: Large and rounded capitals offset the spiky modern cursive script.
Left: An informal style created by using varied pressure in the strokes.

WINE LABEL

*A*lthough some of the most striking calligraphy appears in monotone, color adds a whole new dimension to the art of lettering. Hand-crafted labels are an ideal project for experimental calligraphy. If you have gone to the trouble of preparing your own wine, fruit juice, jam or preserve, you can make labels for the bottles or jars that reflect a creative as well as a practical purpose.

The unusual aspect of these labels for fruit wines is the use of bleach to produce a "reversed" image, either for the decorative motif of the wine glass or for the calligraphy that is applied to the label. You can choose bright colors to represent the different fruit flavors. Drawing into colored ink with bleach is more effective than using white ink, which is not sufficiently opaque, or white paint, which has a tendency to make the color underneath bleed.

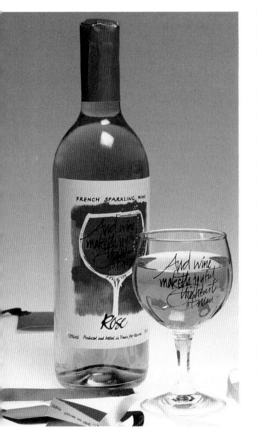

The result depends on the particular combination of paper, ink and bleach, so you will need to experiment with your own materials. Use semi- or fully waterproof colored inks and household bleach. First lay down the base color and let it dry. Then work over the colored area with a pen or a fine brush dipped in bleach. If you find that the bleach spreads then the ink layer may be too thin, allowing the paper to absorb too much moisture. In this case try again with a heavier color base. If necessary you can build up the color base in layers and make sure that you allow each layer sufficient drying time.

Gooseberry

The bleach brings back the original color of the paper, which in these examples is white. But you can also try out different colored papers and you will find that unusual color effects come from the reaction of the bleach with the paper dyes. The quality of light will also affect the appearance of color, so you should work in daylight, or under a daylight bulb.

Raspberry

Left: Build up washes of ink in one color to obtain subtle gradations, or blend two or more colors together. When the ink is dry, draw the motif directly in bleach with a fine brush. If you need a guideline, sketch very lightly first in pencil. Spot bubbles freely down one side of the wine glass.

Left: For graphic contrast, add the calligraphy in black. The script is an informal cursive hand based on italic, written with spiky, flourished strokes.

Left: If you write in bleach with a pen, the strokes are softened where the moisture spreads at the edges.

Lime

ALPHABETS

*T*he alphabet itself offers a natural motif for calligraphy and it is surprising just how many variations of style and layout you can discover, as the examples on these pages demonstrate. These samples have evolved dramatically from the formality of the alphabets featured in the first half of the book

Some calligraphers choose to specialize in inventing new ways of expressing the basic letter shapes and produce sheet after sheet of trials. Successful pieces may stand as original artwork in their own right. As an alternative, a style that is freely devised in this way can then be applied to specific projects, such as a logo, a quotation or a piece of poetry.

If you are exploring the alphabet simply as a visual form, it does not have to be clearly legible, especially if the standard letter sequence is retained. Laid out horizontally or broken into lines or blocks, it becomes as much like drawing as writing, incorporating beautifully expressive qualities of line and tone.

Left and below: Each alphabet has its own distinctive character and consistency, despite the apparent randomness of lines, blots and trails.

Above: Ordinary writing ink is light-textured and gives interesting variations of tone. All these samples were written with the same ink and a wide automatic pen.

QUOTES

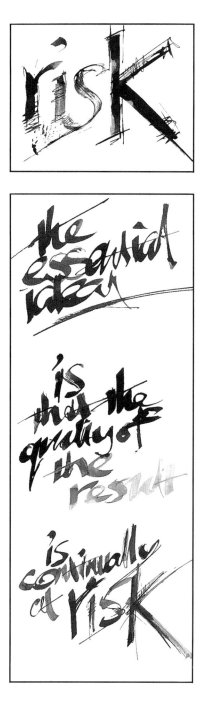

The raw material for calligraphy is always at hand — a well-known phrase, a song title, a famous literary quote, or even a chance remark from everyday conversation. Whatever the meaning of the words, they also have visual form and texture that have to be shaped on the page. Always make plenty of rough workings, exploring both suitable lettering styles and ways of fitting the words together. For a formal piece like the quote in capitals illustrated below, planning the line lengths to create a balanced effect is a large part of the work. In the other cursive samples, the layout tends to evolve with the movement of the pen; but often a perfect sense of spontaneity in a finished piece belies the fact that many versions have already been tried and discarded.

Above: Trial workings test the textural qualities of the writing and the fit of the words.

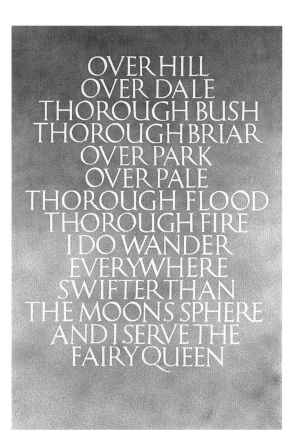

*Opposite: Formal
Roman capitals written
in masking fluid are
washed over with color
to create reversed tone.
Above and right: Two
designs, in different nib
sizes using writing ink
on cartridge paper,
feature strong outline
shapes and internal
rhythms that are appro-
priate to the words.*

POETRY

*L*onger texts are a challenge to the consistency of your calligraphic style, but they also offer great opportunities for creative interpretation.

Stylish black-and-white lettering can be particularly fine, but atmospheric color treatment also has exciting potential. In the extended verse quotation that is illustrated below, some of the pale text is achieved by writing in masking fluid. The fluid dries to a hard rubbery finish and can then be brushed over with color, and is later peeled off to reveal the "negative" or reversed-out letterforms. Some of the text is also written on the colored ink with white paint. By contrast, the free-textured poem that is illustrated opposite is written in dark ink on a thickly painted gouache base.

Below: This complex layout has been carefully planned to fit the featured words that are highlighed in capitals with the wave-like lines of informal script that are aligned across a trio of colored panels.

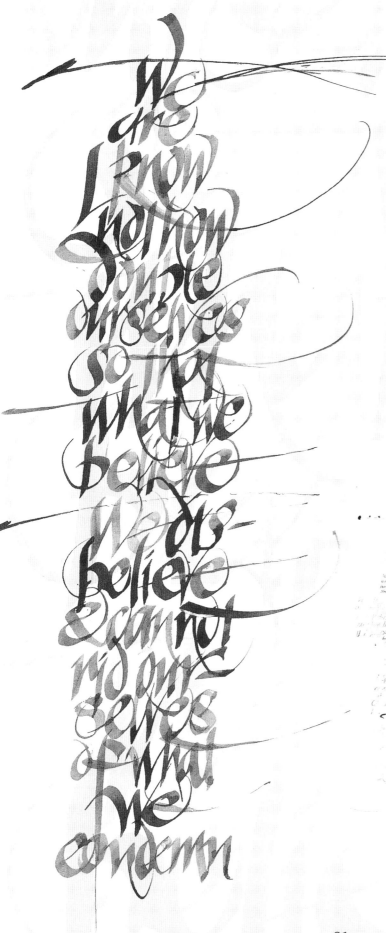

Left: Lively, weighty italic script works equally well in a freely centered layout and a more formal, closely written left-aligned block (far left).
Below: Ink, paint and pressed plant material contribute to this striking, free design.

BOOKS

*H*and-made books are a traditional field of calligraphic work, and some beautiful modern examples have been produced. Hand-written titles may also feature on printed, commercial book jackets, sometimes to imply a sense of quality and craft. However, calligraphy is now so varied and in tune with modern graphics that it can simply be a desirable alternative to type.

Below: A page from a book of quotations from Dante's Inferno. *It is beautifully hand-lettered and referenced with a gold stamp.*

CANTO X
The
Heretics in
Burning
Tombs

A hand-made book is written out on separate flat or folded sheets which can subsequently be stitched or bound together in various ways. This creates a delightful personalized project that gives enormous scope to the calligrapher in all areas of the book's design and presentation.

Commissioned book jackets may mean giving form to someone else's idea, or perhaps developing an imaginative response to a book's title and content. Jackets are a major selling point and legibility is obviously important, but so is a design solution that has immediate visual impact.

Left: An unusual and effective use of calligraphy, with letters carved in relief on plaster and then photographed for the book jacket.

Left and top: Book covers or jackets may sometimes be required to help establish a series identity, such as these cleverly layered titles. The two designs are based on versal letters. For more information on versals, see pages 72-5.

POSTERS

A poster is designed to fulfil a dual function. On the one hand it should draw attention to itself and on the other it should supply hard information. This corresponds to calligraphy's purpose of giving visual impact to words, so calligraphic poster design can be particularly successful. The scale of a poster provides the opportunity to use form and color quite boldly. And considering how to handle different levels of information can stimulate exciting ideas about styling and presentation.

Design for commercial graphics is geared to sophisticated technology for combining typeset lettering with hand-written, overlaying images, and printing in full color. But for non-professionals these ideas are adaptable for one-off projects or a limited print-run reproduced by, say, silkscreen printing, color laser copying or computer graphics.

Left: A combination of lettering styles in a design that balances vertical and horizontal rhythms. It is color-printed by silkscreen, from an original in black and white.
Right: Strong colors touched into letters written in pale, diluted ink hold the forms but create random variegation.

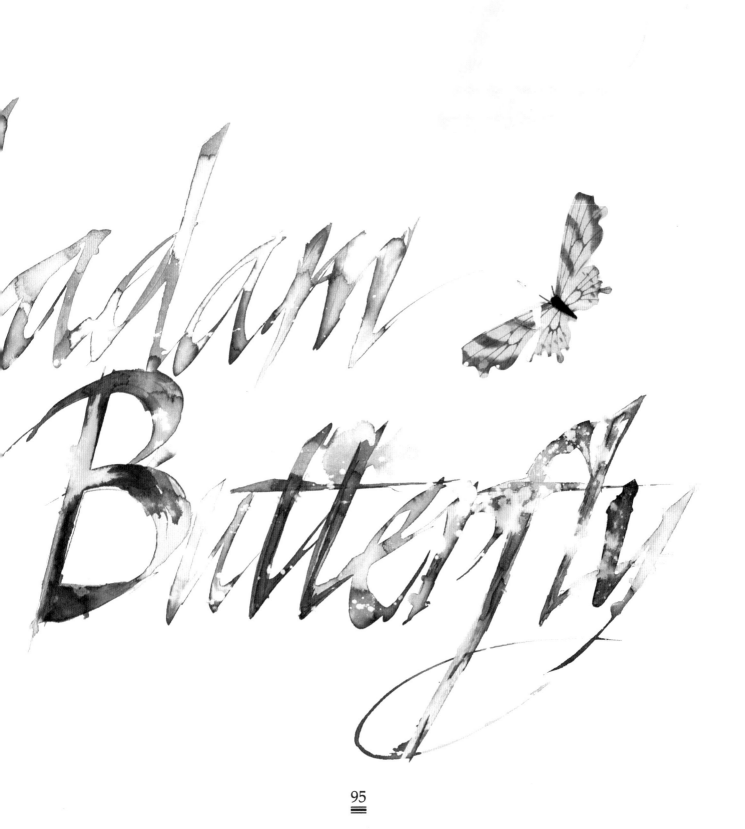

In a completely calligraphic design, there may be considerable variation in the letter sizes, as in the opera poster (see left) that is laid out in blocks of italic script. Large-scale calligraphy presents practical problems for direct writing, although poster pens are useful, being much larger than ordinary nibs. But above a certain size, finding the right tool to work with or controlling the quality of the lettering are both difficult. The best result comes from writing at a suitable scale for your hand and pen, and blowing up the image; this is easily done on a photocopier. This gives an added dimension to the shapes and may reveal interesting edge qualities. Parts of the poster can be written and scaled individually, pasted up on one sheet and copied as a single image.

Above: Crisp italic was written at comfortable broad-nib scale and enlarged to poster size for silkscreen printing.

Left: This rough-edged quality comes from writing on textured paper and scaling up.

Above: Clean sans-serif type contrasts well with free italic script in this poster design.

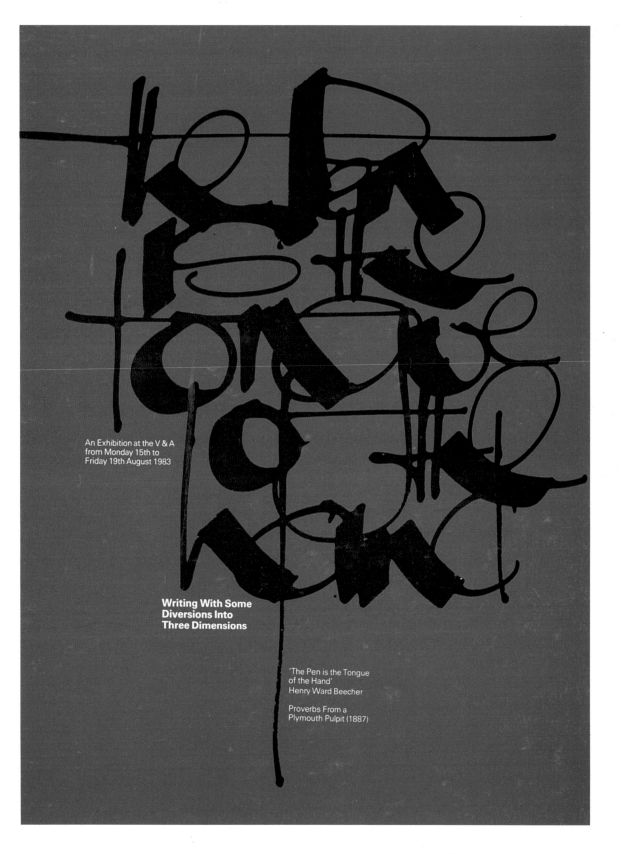

An Exhibition at the V & A
from Monday 15th to
Friday 19th August 1983

**Writing With Some
Diversions Into
Three Dimensions**

'The Pen is the Tongue
of the Hand'
Henry Ward Beecher

Proverbs From a
Plymouth Pulpit (1887)

*Above: The thick and thin pen strokes have a sculptural
quality when enlarged, which dominate the type blocks.*

Combining calligraphy with type means that information which must essentially be easy to read, for example, dates, times, venue or telephone number, can be clearly typeset. At the same time there is more scope with the calligraphy, which can play a more active, illustrative role. These different elements of the poster can either be separated or fully integrated in the design. A monochromatic or somewhat limited color range provides a sense of unity travelling through the whole image. High-contrast black and white is always dynamic and legible.

Right: For a modern-dress Rigoletto, fine calligraphic script turns the title into gunsmoke.

Left: This striking, moody image is the result of overlaying a photographic print with calligraphy on acetate film. The tones and textures of the separate elements are thoughtfully integrated.

Left: Lightweight type and fine calligraphy are well matched and inventively combined, on a cardboard-print tonal background.

Right: The startling message of this poster is announced by stark black and white contrast and spiky, slashed script. The tonal reversal cutting across the rectangle separates the calligraphy from the type very effectively.

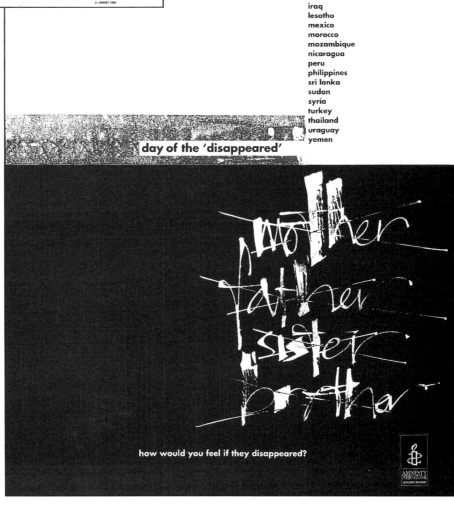

argentina
chile
columbia
dominican republic
east timor
ecuador
el salvador
guatemala
honduras
india
iraq
lesotho
mexico
morocco
mozambique
nicaragua
peru
philippines
sri lanka
sudan
syria
turkey
thailand
uraguay
yemen

day of the 'disappeared'

how would you feel if they disappeared?

RECORDS

*D*esigns for record sleeves follow much the same considerations as those for posters (see pages 94-9) and book jackets (see page 92-3). Namely a potential good marriage of hand-lettering and type, variations of scale and legibility, and an interpretive use of color. Both the mood of the music itself or the category, classical, rock, jazz or any other, can inform the calligrapher's design ideas.

The examples shown here illustrate interestingly contrasted approaches. Texture and movement within the letterforms come from the bleached and variegated colors (see below). While an elegant series style (see opposite) depends on beautifully crafted titles executed in strong, plain colors.

blood women roses

one thousand years
cry me a river
we'll fall apart

still a child

side

side

come out

the man i love

red rose

blood on your hands

By Malcom McLaren

Overture
Prologue: Jellicle songs for jellicle punk
The naming of punks
The invitation to the punk ball
The old gumbie punk
The rum tum tugger

Grizabella
Bustopher punk
Mungojerrie and rumpelteazer
Old deuteronomy
The London punk
The railway punk
Mr and Mrs Punky
The addressing of Punks

Above: Repeated scratchy strokes used in conjunction with bleached-out color give an attractively raw calligraphic style.
Left: Slightly watered colors blossom and spread away from the main strokes.

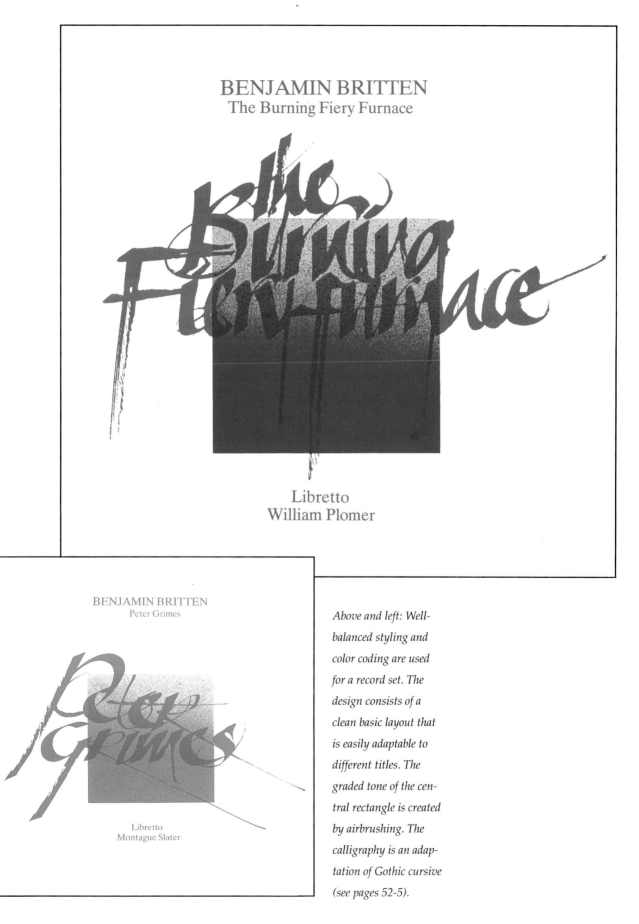

BENJAMIN BRITTEN
The Burning Fiery Furnace

Libretto
William Plomer

BENJAMIN BRITTEN
Peter Grimes

Libretto
Montague Slater

Above and left: Well-balanced styling and color coding are used for a record set. The design consists of a clean basic layout that is easily adaptable to different titles. The graded tone of the central rectangle is created by airbrushing. The calligraphy is an adaptation of Gothic cursive (see pages 52-5).

FREEFORM LETTERING

For some calligraphers, the orderly character of standard alphabet forms is a large part of the pleasure that they take in the craft. However, for others, learning the basic techniques is only a starting point for adventurous lettering design and graphic experiment. And as with ordinary handwriting, every calligrapher injects a sense of their own personality into their own work.

Left: Thick and thin contrast is varied by turning the broad nib onto its outer edge. Below: Two nib sizes applied to a flowing variant of italic. Below left: Colored writing created with a five-pronged nib.

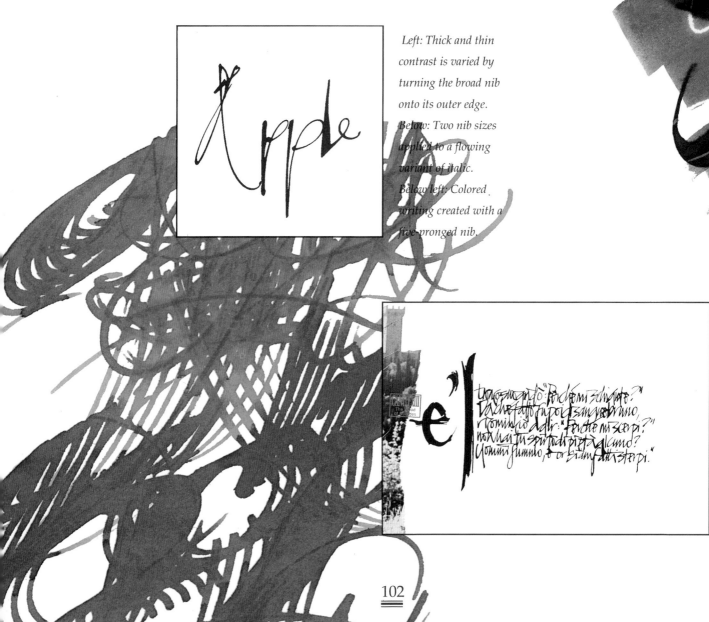

The examples shown on these pages illustrate how different styles and features can occur as you gain confidence and learn to manipulate the pen quite freely. As you apply the full width of the nib to the page, or turn it on its edge in order to create thick-thin variations, try to separate the strokes or run the pen right around a particular form and you will randomly discover new line qualities. Experimenting with a range of writing materials is also good practice. Why not try an unfamiliar writing tool, such as an extra-broad pen or a multi-stroke nib? In addition, investigate the versatility and impact of color in the lettering itself, or as a background.

Above: Broad strokes in colored ink written over with a finer nib charged with bleach. Left: Thick strokes extended as the ink runs out reflect the mood of the words.

Right: One of several contrasting samples of the word "Macbeth". This version has fuzzy edges due to the use of diluted Chinese ink on absorbent newsprint.

Above: Here, the thick strokes were achieved with a sable paintbrush and Chinese ink on watercolor paper.
Left: An automatic pen allows more distinct thick and thin contrast of the strokes.

Left: In order to convey the Japanese interpretation of a production of Macbeth, *this sample for a poster design was worked with a Japanese calligraphy brush on cartridge paper.*

Experimental calligraphy does not have the same requirements of legibility that formal pieces do, but you do need to consider the context of your work. A piece of calligraphy that is written or designed for your own interest can become very richly visual, rather like a painting. On the other hand, with a commissioned or publicly displayed work, communication is all-important. The boldness of your solution also depends on the amount of calligraphy lettering that is used, and whether there is easily readable back-up, such as lines of type, as in a poster or a book cover.

The variations of the Shakesperian play *Macbeth* that are reproduced on these pages were executed for a poster design. The well-known drama was to be staged in Japanese style and the traditional setting transposed to a 16th-century Samurai world. The calligrapher managed to convey the Japanese warrior theme in the lettering shown here.

It is not always taken into account how strongly the paper surface can affect the look of calligraphy. When the writing tool glides easily across the surface of, say, bond or cartridge paper, the pen or brush strokes tend to appear whole and crisp.

Above: This variation of Macbeth *was worked with a sable paintbrush and Chinese ink on art paper.*

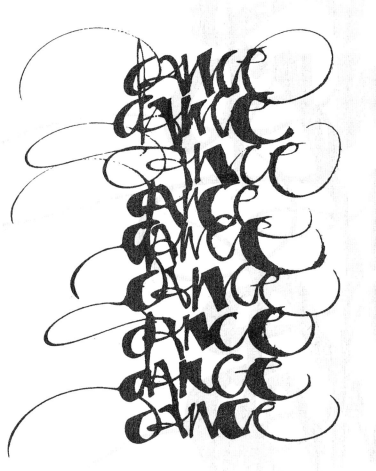

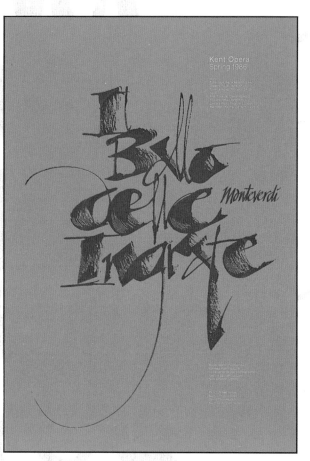

Above: Part of a poster for a contemporary dance; more elements of the design are shown right and opposite.

Above right: Lettering worked with a very large nib and semi-dried paint.

Left: The repeated words "dance", shown above left, combine with this dynamic lettering worked with an automatic pen and ink on art paper.

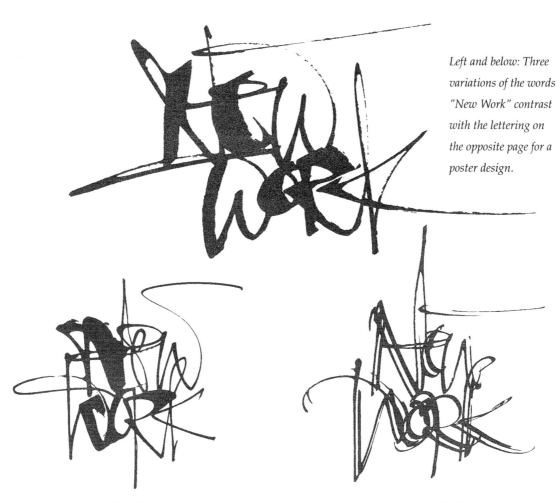

Left and below: Three variations of the words "New Work" contrast with the lettering on the opposite page for a poster design.

Above: Spiky lettering in ink denotes a dynamic "New Work".

Above: A twin-nibbed pen produces a distinct effect in ink.

However, if you work with varying weights and finishes of textured watercolor paper, the smoothness of the stroke and its edge qualities are naturally altered. And a paper which has a napped and slightly absorbent surface allows the ink or other media to spread gently and fuzzily out from the main strokes.

The examples of calligraphy shown on this page (see above) which read "New Work" were designed in conjunction with the lettering opposite as part of a poster design to advertise a dynamic performance of modern dance. The words on the page opposite were quite legible, but in order to clarify the meaning of the expressive formations of the words "New Work" they were reinforced with type.

By using a single broad pen, you can devise endless variations of visual effect. Altering the pen angle or size of the lettering creates different kinds of texture. Some calligraphers experiment with materials that can imitate the action of the pen but are not purpose-made — strips of wood or cardboard, for example. As these materials have no reservoir for ink, the flow quickly runs out, creating interesting broken, textured and jagged strokes, often accentuated with gradated tone or scratchy outline forms.

The actual width of the writing tool ultimately governs the size and density of the lettering you can produce. The thickest stroke, whatever the character of your alphabet forms, is no wider than the nib.

Specially large poster and automatic pens increase the range of style possible, but a cardboard strip can be wider still. An alternative approach to varying the size and texture of the lettering is to work on quite a small scale and blow up the result on a good-quality photocopier. This reveals positive and negative shapes, thick and thin contrasts and edge qualities in a different way, giving you new insights.

These pages demonstrate how a calligrapher has developed various styles of lettering, including an elaborate initial F (see left) for a poster promoting a well-known Mozart opera.

Above left: An initial worked in gouache. Left and bottom left: Variations in black ink on art paper.

Left: To create a less flourished effect, this initial was achieved with an automatic pen and black ink on watercolor paper.

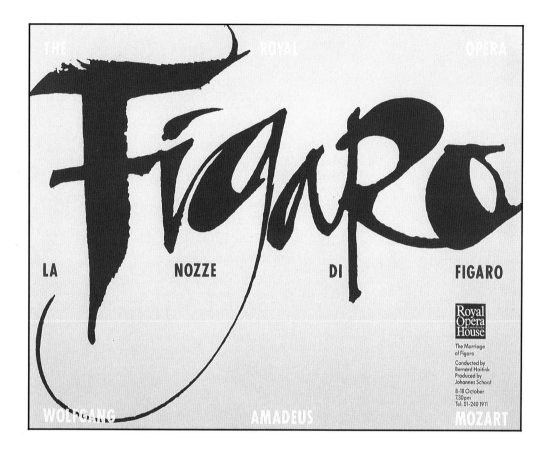

Above: The lettering in this finished poster
design are based on 18th-century forms.

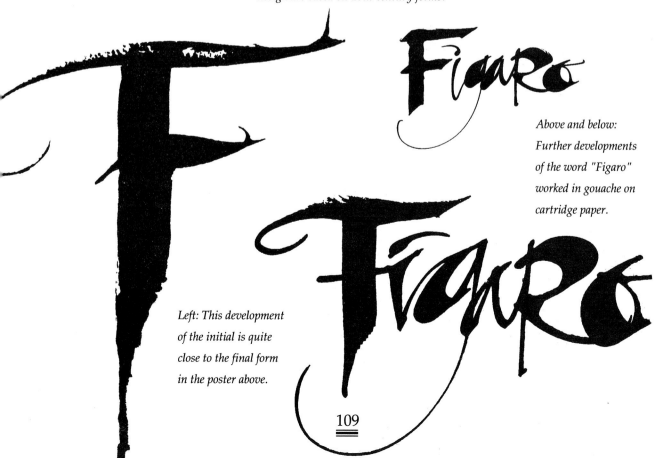

Above and below:
Further developments
of the word "Figaro"
worked in gouache on
cartridge paper.

Left: This development
of the initial is quite
close to the final form
in the poster above.

INDEX

ACKNOWLEDGMENTS

Miriam Stribley and the publishers would like to thank the following

calligraphers for allowing their work to be reproduced in this book. The names given

below are the individual copyright holders of their work.

Stephanie Ager: page 23

Matthew Biggs : page 83 (top and bottom), page 99 and page 102 (top left)

Alison Carmichael: page 93 (middle) and page 98 (bottom)

Neil Lang: page 88 (left) and page 93 (top and bottom)

Wallex Leung: page 22 and page 98 (top)

Mei Mak: pages 84-5, page 95 and page 100 (bottom left)

Rachel Parfitt: page 82 (top and bottom)

Barry Parker: page 24, page 102 (bottom left) and page 103 (top)

Terry Paul: page 3, page 26, pages 86-7 and page 89

Paul Reid: page 91 (right)

Dean Robinson: page 101

Karen Sawyer: page 94 (left)

Betty Soldi: page 92, page 96 (right), page 102·(bottom right) and page 103 (bottom)

Nick Stewart: pages 1-2, page 88 (right), page 90 (bottom) and page 96 (top left)

Paul Tilby: page 100 (top and middle right)

Rachel Yallop: page 80 (left and top) and page 81 (top and bottom)

Fraser Watson: page 5, page 7, page 21, page 27 (top),

page 96 (bottom left) and pages 104-109

The publishers would also like to thank Stuart R. Stevenson at 68 Clerkenwell Road,

London EC1M 5QA for his assistance in supplying the materials photographed in

the Materials and Equipment section.